BERENICE ABBOTT

DIANE ARBUS

MARGARET BOURKE-WHITE

JUDY DATER

FRANCES BENJAMIN JOHNSTON

GERTRUDE KÄSEBIER

DOROTHEA LANGE

BARBARA MORGAN

BEA NETTLES

ALISA WELLS

THE WOMAN'S EYE

edited and with an introduction by ANNE TUCKER

ALFRED A. KNOPF NEW YORK 1973

A COLLINS ASSOCIATES BOOK

THIS IS A BORZOI BOOK
PUBLISHED BY ALFRED A. KNOPF, INC.

Library of Congress Cataloging in Publication Data
Tucker, Anne, comp.
 The woman's eye.

 "Selections from the work of Gertrude Käsebier, Frances
Benjamin Johnston, Margaret Bourke-White, Dorothea Lange,
Berenice Abbott, Barbara Morgan, Diane Arbus, Alisa Wells, Judy
Dater, Bea Nettles."

 1. Photography, Artistic. 2. Women photographers.
I. Title.
TR650.T78 1973 779'.092'2 73-7283
ISBN 0-394-48678-1
ISBN 0-394-70626-9 (pbk.)

Composed in Optima by Precision Typographers
Printed by Rapoport Printing Corporation
Bound by Sendor Bindery
Manufactured in the United States of America
First Edition

175751

SOURCES AND ACKNOWLEDGMENTS

The editor and publishers are most grateful for the cooperation and generous assistance of the following in providing material for this book:

Berenice Abbott, Judy Dater, Barbara Morgan, Bea Nettles, Alisa Wells. Doon Arbus and the estate of Diane Arbus, for all the Arbus photographs and quotations from *Diane Arbus: An Aperture Monograph*. Miss Mina Turner, for permission to publish all the Käsebier photographs and for Steichen's portrait of Käsebier. The Collection of Peter C. Bunnell, New York, for Käsebier's *Portrait of Sadakichi Hartmann*. The Collection of the International Museum of Photography, George Eastman House, Rochester, N.Y., for Käsebier's *The Sketch*. The Library of Congress, for Johnston's photographs and for Lange's *Sharecropper and family*. The Collection of the Museum of Modern Art, New York, for Käsebier's *Blessed Art Thou Among Women*, Platinum print, 9⅜ x 5½ inch, *The Manger*, Platinum print, 12¾ x 9½ inch, *The Heritage of Motherhood*, Platinum print, 9¼ x 12-7/16 inch, *The War Widow*, Platinum print, 8⅞ x 7¼ inch, *The Picture Book*, 9⅞ x 13 inch, gifts of Mrs. Hermine M. Turner; *Portrait of Clarence White and his mother*, Platinum print, 9½ x 7½ inch, *American Indian portrait*, Platinum print, 8 x 6 inch, gifts of Miss Mina Turner; *Happy Days*, Plate IV from *Camera Work X*, Gravure, 8 x 6½ inch, gift of Wm. A. Grigsby; and for Johnston's *Adele Quinney*, Platinum print, gift of Lincoln Kirstein. The Dorothea Lange Collection, in The Oakland Museum, Oakland, California, for Lange's photographs. The Time-Life Picture Agency, for the Bourke-White photographs. Light Gallery, New York, for permission to use the Nettles photographs. The Witkin Gallery, New York, for permission to use the Dater photographs.

To the following magazines, newspapers, and radio stations from which references appear: *Afterimage, Aperture, Art Forum, Art News, Image, Image Nation, Infinity, Modern Photography, Ms., Newsweek, Popular Photography, The Print Collector's Newsletter, Saturday Review, U.S. Camera, Houston Chronicle, Washington Post, Village Voice, Women and Art, The Craftsman, Photographic Times, Ainslee's Magazine, Cornell Alumni News*, WNYC, WRVR, and WBAI.

Furthermore, the editor is indebted for research assistance to the staffs of the International Museum of Photography at the George Eastman House; Prints and Photographs Division, Library of Congress; Photography Department, Museum of Modern Art; the Visual Studies Workshop, Rochester N.Y.; and to Jerry Kearns and Ted Theisen.

To four influential works: Carolyn G. Heilbrun's *Toward a Recognition of Androgyny*; Herbert Marder's *Feminism and Art: A Study of Virginia Woolf*; Simone de Beauvoir's *The Second Sex*; and Virginia Woolf's *A Room of One's Own*.

To Peter C. Bunnell, Pete Daniel, Raymond W. Smock, Doon Arbus, Marvin Israel, Grace M. Mayer, Linda Nochlin, Lucy D. Lippard, and Therese Heyman for sharing their scholarly notes; and Barbara L. Michaels for new research in dating the Käsebier photographs.

Finally, special thanks are due to Nathan Lyons and John Szarkowski for their seminal influence; the Spring 1973 class in "Women and Photography," at the New School for Social Research, New York, for being willing and helpful guinea pigs; to Alison Bond of Collins Associates; to all the women whose lives have served as examples, especially Mrs. Geraldine Wilkes Tucker Wallace and Joan Lyons; and in particular, for his encouragement, unfailing assistance, and patience as a husband and friend, to Cal K. Cohn.

A.T.

INTRODUCTION

Is anatomy destiny? We are a very long time away from answering this question. All the data currently available reflect the differences between women and men imposed upon us by the patriarchal society in which we live. As long as the divisions between women and men are so rigidly defined and enforced, it is impossible to know whether any differences occur naturally, and if they do, whether they bear any relation to the traditional stereotypes. Both women and men agree that differences exist; it is the nature of those differences and their origins that remain in dispute.

Many women have begun to question the relationship between their sex and their art. Are certain sensibilities uniquely feminine? Can these be deciphered in a particular individual's art? Can and should art be distinguished as women's art or men's art? Can a woman's art be received fairly in an art world dominated by men? Most of the discussion of these questions has been concerned with literature and visual arts other than photography. It is the purpose of this book to consider photographs made by women—and by doing so to re-evaluate some of the ways women are portrayed by men.

Specifically, the work of ten twentieth-century American women is presented. When discussing both art and sex, it is much easier to remain within the cultural confines of one country. Ten is an arbitrary number; it could just as easily have been a book of twenty or fifteen or eleven.

Those included are Gertrude Käsebier, Frances Benjamin Johnston, Margaret Bourke-White, Dorothea Lange, Berenice Abbott, Barbara Morgan, Diane Arbus, Alísa Wells, Judy Dater, and Bea Nettles. These photographers could have been replaced by others, equally as talented but with their own styles and interests. Among those missing are Imogen Cunningham, Doris Ulmann, Anne W. Brigman, Lotte Jacobi, Laura Gilpin, Lisette Model, Marion Palfi, Naomi Savage, and Marie Cosindas, to name but a few.

If nothing conclusive emerges from this book, at least central questions will be raised and partially defined. There are those like Berenice Abbott who will ask, "Why bother?" The answer is that consciously or unconsciously, even unwillingly, we all respond to art on an emotional as well as an intellectual level. Consequently, knowing a photographer's sex influences our judgment of the photographic content and even its value. Awareness of the roots of our response may provoke change in our overall responses to both contemporary work and to photographs from the past.

Before taking up the question of "women's art," it is important to consider the status of women artists in society. Although women, like men, suffer from the indifference and neglect common to most artists, there are many more social and economic barriers imposed upon women, which drain their energy and, through the anger provoked, cripple their talent. Economic discrimination, in the denial of jobs, fair wages, and equal advancement, discourages women from working as artists. Relatively few artists are able to support themselves solely from the sale of their art, and until the late 1960s most art photographers didn't even consider that a possibility. Very few museums or private collectors bought photographs, and even when they did, paid so little for them that only portraitists and photojournalists were able to find steady employment. Unable to sell their serious work—the photographs they made for themselves

and exhibited—photographers had to produce something commercially viable or find other jobs to support themselves. Since World War II, the situation has improved a little; photography as an art form has gained increasing institutional recognition, and with it has come jobs for teachers, curators, editors, and critics of photography. But photographers were rarely offered these jobs, particularly if they happened to be women.

A further aspect of the double standard is that men are expected to have careers, while women are usually discouraged from becoming working professionals: they are expected to prefer as full-time the role of wife and mother. Many women photographers, including Dorothea Lange, Barbara Morgan, and Diane Arbus, have managed both careers and families. The problem is one of balance: how to allocate time and energy. Art demands great concentration and discipline, but if women cannot afford help or don't receive some assistance from their husbands, the blocks of time needed to sustain such effort are an unattainable luxury. Often their art must be worked in with all of the other responsibilities of their day. Judy Belasco—a photographer who is also a wife, a mother of two girls aged eight and nine, a student, and a teacher—recently described a typical day of juggling.

> Unmount prints—talk on the phone—wash kitchen floor—instruct students in darkroom—go to store—think about my past work—wash prints—visit closest woman friend—discussion of work, writing, children—pick up her child—go buy food at co-op—home, watch husband's pilot TV/radio project—dinner—school, nun lecturing on evolution—home—dance and verbalize to husband about experience—read in front of fire with kittens jumping all over bed. . . .

Women must also deal with the powerful factor of guilt: guilt for spending time on one's art and not with the children, guilt for not doing something demonstrably useful, and guilt for spending money on "inessential" supplies when no extra money is coming into the household.

Society's double behavioral standard for women and for men is, in fact, a more effective deterrent than economic discrimination because it is more insidious, less tangible. Economic disadvantages involve ascertainable amounts, but the very nature of societal value judgments makes them harder to define, their effects harder to relate.

Gertrude Käsebier and Alisa Wells avoided many of these problems by not beginning their photographic careers until their children were older, even though Käsebier always wanted to be an artist. If a woman chooses not to have children—or, more suspect, not to get married—many historians feel compelled to offer an explanation. Unwilling to admit any deliberate, conscious decision by the artists, they suggest that the woman was personally unattractive or abrasive, implying that she was never asked to marry and therefore her artistic ambition arose from frustration.

Determination and endurance to surmount economic and cultural barriers alone will not ensure a woman artistic success. Not only must she find the time and energy to create, and establish her right to do so, but she must know what she wants to express and how best to express it. To achieve this, any artist has to explore and take risks, but so often a woman is handicapped by

her public image as a woman. More damaging for her art than any of these restrictions, she is instilled with fear. All art requires courage. Whether it involves revealing the previously unexplored or renewing something intensely familiar, the artist must be committed to the search and to her discoveries, a particularly formidable factor if they challenge basic social principles.

Exploration, whether of jungles or minds, is considered unfeminine and dangerous. Men are expected to develop their minds and bodies and to learn the limits of their capabilities. The competitive games of boys are part of society's program to give men a sense of their intellectual and physical selves. Women are denied this kind of stimulation and encouragement. By protecting them, society harnesses their independent growth and undermines their courage. Beyond the realm of fashion, women are not encouraged to be original, but to look for approval.

Rather than develop their intellectual sense and regardless of personal inclinations, many women are directed by societal pressures to develop their intuitive faculties. The image of woman as emotional and spiritual, and of man as rational and scientific, affects what women and men demand of themselves and what they see as expected forms of behavior. Men are trained for administrative positions in which they are expected to deal abstractly in types of people, or patterns of behavior; whereas society expects women to take on roles of service requiring a sensitivity to the specific needs and preferences of specific people. Considering the emphasis placed on women's intuitive ability with people, it is hardly surprising that some women artists have utilized skills of perception and empathy in their art. In twentieth-century America, ninety percent of the women photographers have been portraitists, journalists, and documentarians, whose primary concern has been people.

Is there in fact a women's art? Or, to put it in another way, can the sex of the artist be identified through the art? That depends both on the art and on the basis used to make the distinction. The public often assumes certain distinctions between men's and women's art. General audiences find differences in the artist's attitudes, and they describe these differences using the same adjectives with which they typically describe masculine and feminine behavior. Men are assumed to be personally more detached from their subjects—clinical, rather than compassionate in their observations. Men are supposed to be witty; women humorless. Women, they say, make soft, delicate pictures. Women, they say, are not harsh, hostile, or cruel. Such generalities, based on the culturally enforced stereotypes, are inaccurate and misleading when applied to specific photographs. According to such standards, the quiet perceptiveness of August Sander's portraits, for example, should be of feminine origin, whereas the clear, impersonal vision of Berenice Abbott would have to be considered masculine. W. Eugene Smith's compassion is remarkable, but is hard to fit in the masculine model. The images of Diane Arbus and Lisette Model are anything but soft and delicate.

Traditionally, however, critics have a more studied, complex approach to art. They have distinguished one artist's work from another's on the basis of style: how the subject matter is handled, what tones and colors recur in the artist's work, what format is used, what processes, and so on. Some feminist art critics have described stylistic elements that they believe to recur in women's paintings. For instance, Judy Chicago of the California Institute of Arts Feminist

Program finds a central focus or void in women's paintings. Similarly, art critic Lucy R. Lippard describes "the preponderance of circular forms and central focus." Other women have argued that these same qualities are found as readily in men's work. As painter Marjorie Kramer replied to Ms. Chicago, "Henry Moore does holes as much as Georgia O'Keeffe."

It seems unlikely that stylistic distinctions can be found in the photographs of one sex to the exclusion of the other. Styles belong to a time and place, and artists within that time/space share stylistic concerns. Stylistic properties may define and isolate the arts of different civilizations, and even of subcultures within a civilization, but the interchange between artists within a particular culture prevents distinctions on anything other than personal bases. In our society, the lives of women are distinctly different from the lives of men, but the differences are too fragmented to be defined as distinct and separate cultures. The differences become evident only when the photographers consciously confront their sexuality in their art. The degree to which being a woman may influence a photographer's work is dependent upon the extent to which she uses her art to confront her existence as a woman.

Not all women have wanted to deal with themselves as women in their art. Frances Benjamin Johnston, Margaret Bourke-White, Berenice Abbott, and Diane Arbus are very private people. Their concerns are completely with external reality, not with personal relationships nor with inner preoccupations. They keep themselves out of their art as they also conceal their private lives from public view, or at least they have been very selective about what is revealed and what is considered too personal.

The photographs made by these four women are those the public is most likely to assume were made by men. Each decided on an external subject she wished to study and proceeded to define it clearly in relevant terms. They were all very detached; their photographs don't reveal any personal feeling toward their subjects, but maintain a strictly rational and deliberate approach. Their desire is to describe, to inform with facts; their images are rich with detail, yet clearly straightforward. Each printed her negatives simply, without noticeable manipulation and usually without cropping, full frame.

All four of these women were full-time or part-time magazine photographers, thus earning a living in photography's most competitive field. Although women are not supposed to be competitive or explorers, they were adventurous and placed themselves physically in situations or involved themselves in tasks which were considered improper, or at least unlikely, for women. Each would use men for protection when convenient, yet ignore them when it was not convenient. Because they refused to be conventionally feminine—refused to defer—some photographers tended to resent them. Margaret Bourke-White was probably the most aggressive in that she was the most ambitious, and as such, she reaped a lot of criticism. As *U.S. Camera* observed in 1941:

> Photographers don't like Bourke-White. Toni Frissell, Louise Dahl-Wolfe,
> they're the girls the good photographers like. They're also the girls who do
> things the feminine way—the *Harper's Bazaar* and the *Vogue* way. But
> Bourke-White not only steps on photo-male toes—she gets in photo-male
> hair. She can match his words—write a better book—take a longer chance.

Yet some of the men who have found these women obnoxious as persons turn out to be their staunchest supporters as photographers. They admire the courage, self-discipline, and rational approach of their work. The images of Bourke-White, for example, that they most respect are her early ones of machines, those devoid of emotion except for a tremendous sense of power. It is thus on the rational, factual plane that women's and men's photography converges most successfully, not on the personal.

Dorothea Lange made photographs which in many ways are very similar to those of Johnston, Bourke-White, Abbott, and Arbus. She was also interested in the external world and described it in a straightforward way with facts and relevant detail. However, she was not as detached from her subjects as the other four preferred to be. Her approach was intuitive as well as rational; she became involved on both intellectual and emotional levels. Lange had an androgynous mind, one in which the masculine and feminine elements were in balance. Which masculine and feminine characteristics she integrated in her work can best be clarified by a comparison between Lange and Arbus.

Both Arbus and Lange photographed people almost exclusively. Both were uncommonly tough in pursuing their photographs. As Peter Bunnell observed, "each of these women could enter a situation that might destroy many people and photograph, and then withdraw from the edge." Each would peculiarly establish an intense rapport with her subjects, a relationship best described by Lange's son, Daniel Dixon.

> Dorothea Lange, the person, is as complicated as is a definition of her work. Even her closest friends cannot take hold of the fact that the woman they know is not the only Dorothea Lange. Deceived by her simplicity of manner and intimacy of spirit, they fail to see that she is a many-sided person who in giving herself as wholly as she can to whatever she's doing, whoever she is with, wherever she is, makes each of her many sides appear a complete person in itself. This is the kind of complexity, of course, over which friends are entitled to squabble a little; but it is also the kind of sympathy which, even behind a camera, can convert suspicion to trust and hostility to warmth—particularly when its rush of impulse is so unstudied as hers.

Doon Arbus has observed a similar concentration that seduced the subjects into trusting her mother, and into submitting something of themselves in the belief they had received something in turn.

The difference between Arbus and Lange lies in their approach, and the reasons why they chose to photograph. Diane Arbus was ambitious. She wanted to carve out a place for herself where nobody else had ever been. As she herself expressed it, "There are things which nobody would see unless I photographed them." And as John Szarkowski observed, "There is something untouchable about that kind of ambition. You can't manhandle it." Lange had a more gentle intent. She did not want to introduce, but to remind us of things. Hoping to leave the world a better place than she had found it, she wanted to preserve human experience for future generations. Through her early photographs of California's migrant workers, she aimed to shock the nation's conscience and to provoke action on the destitute workers' behalf. In her later

work, she offered a spiritual legacy of everyday things "taken for granted not only by our eyes, but often by our hearts as well."

Arbus's delight was in the telling; she had no axe to grind, no social grievance to protest. She wanted the viewer to be interested in what *she* had made. She was not interested in communicating or communing with anyone. For her, "A photograph is a secret about a secret. The more it tells you the less you know." Lange's pleasure lay in the sharing. She believed in mutual understanding between peoples and in photography's role as an international language. Lange hoped her photographs would help people feel, and feeling, understand one another's problems.

Although she valued the weight of external reality, Lange sought the truth, the timeless forces responsible for coherence and order in the physical elements. Here she is joined by most serious photographers, each with his or her own understanding of what those forces are and how they may best be expressed. Johnston, Bourke-White, and Abbott searched within society and expressed their findings with logical sobriety. Morgan and Lange, androgynous by nature, were guided by reason and discipline, but functioned intuitively. The profound beauty in their photographs is of the kind associated with home and friends, not with the "real" world of business or politics. Whereas Lange was interested in the everyday quality of life—the events of human existence and the human consciousness behind the externals—Morgan has found the unifying forces more cosmic, predominantly an awareness of life's natural rhythms: growth and decay, repetition and climax.

This concern, as mentioned earlier, is a natural one for women to utilize in their art, since society frequently assigns it to them. For Lange, Morgan, and Käsebier, it dictated their exercising moral values in selecting what to photograph, or what to convey. Theirs is not a purely rational truth, but one that deals in matters of the heart as well as of the mind. Each would probably have agreed with Nathan Lyons that "Intellect, as an isolate consideration, with an unrelated concern for the interaction of our senses, represents a brittle human state." Each has emphasized the importance of an empathetic relationship between subject and photographer, or control achieved not through intimidation but with sympathy and warmth. They believe that art should affirm life. Each is especially opposed to the overly sensational and dramatic, preferring the familiar and intimate. From their personal experiences, both daily and eventful, they portrayed what they best understood and what they wanted others to understand. What lifts this above the mundane is the rigor with which they pursue meaning, the clarity with which they articulate their unique visions. Each has sought the symbols and expressive style most conducive to her creative and personal needs. Lange preferred the straight photograph. Käsebier, Morgan, and Wells find the most expressive freedom in manipulated images, although all three also utilize the straight approach.

In photographing that which is most dear, that which they respect, Käsebier, Lange, Morgan, and Wells all deal with themselves as women in some aspect of their art. Lange's identification with rural women resulted in the series she titled "The American Country Woman." Morgan's involvement with her own children's experiences at summer camp led to her book *Summer's Children: A Photographic Cycle of Life at Camp* (1951). Gertrude Käsebier was a commercial

portraitist, yet she is best known for her series of photographs on motherhood. She made hundreds of images, both metaphoric and specific, expressing a feminine view of that very feminine experience. They include some very personal interpretations of motherhood in which the loneliness, suffering, and sacrifices of her own experience are exposed. Yet Käsebier's break with traditional views was only partial. In all of her portraits, and in some of the motherhood series, she still worked from the masculine standard of "fair women and famous men."

Women who attempt to explain themselves through their art face tremendous problems in trying to explore their feelings. They are provoked by the discrepancy between what they feel about themselves and how they have been taught to feel. For centuries men have defined themselves in terms of other men, but women have been defined by and in terms of men. Men's projections have permeated everything, making it harder for women to isolate their own feelings and less likely that their art will be received with encouragement in a patriarchal society.

The ubiquitous nature of masculine images of Woman has contributed significantly to the struggles of women artists because that which is publicly acceptable art does not conform with their own needs and experiences, and their own art does not conform with popular standards. For a time, Wells was overwhelmed by this conflict. After several years of working almost purely intuitively, evolving intensely personal visual metaphors, yet functioning as a traditional woman in a male-dominated intellectually oriented community, she turned inward, venting her feelings of inadequacy, and expressing her self-hatred, loneliness, frustration, and anger.

Some curators refuse to deal with Wells's imagery. In fact, they are uncomfortable with the work of most of the intuitively directed photographers, male or female. Because of photography's ability to record with infinite detail, they assume that it is most congenial to rational expression. In fact, they believe that the rational approach is the only proper one to the medium. Poetical connections are elusive and irritating to those who expect order; emotional intensity alienates those in an urban society who believe such spontaneous expression is associated only with the naïve. In a cynical, sensation-oriented art world, sympathy is rejected as sentimental, intimacy as weakness.

While photographs of women by men are usually intelligible to men, they often find it hard to respond to images by women about femininity. Perhaps it is unfair to expect most men to be receptive to the needs and responses of women, but it is not unfair to expect museums to hire women who could be more responsive. The writing of photography's history and of current criticism, the building of photographic collections, and the publication of most books and magazines are controlled by men; thus the persons who select photography's "masters" and "masterpieces" are men. Curators and editors have found Woman to be a dependably popular theme, and in their annual compilations, photographs of every nature have been lumped together as catalogues for wet dreams. Yet they have been consistently unresponsive to the women whose approaches and concerns are not shared by men. Photographs of women's fantasies that have come into museum and magazine offices for inspection have been good for snickers behind office doors, but not for exhibition or publication.

The photographs most often exhibited, and published, pay homage to man's notion of what woman should be. Men have idealized women, set them apart, made them Other. It has been assumed that there is an Eternal Feminine, against which all women must be measured, but its definition has remained vague, if not intentionally contradictory. Photography has played a unique role in perpetuating the conflict by portraying both myth and reality. In many photographs, women appear as they do in daily life, not set aside as something special. In these photographs, the fact that the subject is a woman is not necessarily important, until the viewer, or perhaps the photographer in retrospect, searches for meaning. But when a male photographer consciously chooses to photograph a woman, he is more likely to deal with the idea of Woman. If he selects a model according to his prejudices, the photograph will be more about his preconceptions than about the actual woman before his camera. Such photographers have used women, privately and commercially, as physical phenomena and as symbols for popular and personal ideals.

Certain myths and ideals about women recur in photography fairly frequently. These can be identified as the glamour portrait, woman as sex object, and the Earth Mother. Most of the major twentieth-century male photographers have recorded their version of the ancient Earth Mother myth. Alfred Stieglitz, Edward Steichen, Harry Callahan, Wynn Bullock, Edward Weston, and Jerry Uelsmann are just a few of those who have photographed women amid the wilderness. Nude women have floated in still ponds, been massaged by rushing waters, prayed at the base of phallic trees, and danced in grassy fields with the wind in their (long, blond) hair on thousands of pages of books and magazines.

Most attempts by women to refocus this masculine concept have failed. It is not that some women cannot identify with the fertile image of the earth, but that they have tried to approach it as a man would, a third party viewing women and the earth from a distance. At the turn of the century, Anne W. Brigman brought an innocuous feminine slant to the theme, photographing herself nude in the rugged Sierra Mountain landscapes, but the images lack vitality or conviction. Approaching it as she did, she might as well have attempted to portray the pleasures of being raped.

Judy Dater recently handled the same theme from a more strongly feminine point of view. In "Aspen, 1969," a female nude, seen from the waist down to the calves of her legs, is silhouetted with her back to the camera. One foot, raised, rests on a low window ledge. To her right is a screen door and just outside is a panting dog staring in. As Dater explained, "The dog at the door is Man."

In some photographs of women taken by men there is a quality of passiveness, of waiting for Man. In these photographs the woman is only a sex object, an object for man's diversion. Soft or metallic, voluptuous or slender—the woman's shape does not matter as much as the fact that her body is undressed, naked, and waiting. The woman may look at the camera, but never stare. That would destroy the inherent voyeurism. She is something to possess, or to dream of possessing. Women have photographed nude women, but the implicit invitation is absent.

Perhaps here too lies the clue to why women have failed to respond to the new male pin-ups. Most women do not assume man is lying there waiting for them. The destiny of men's bodies has always been in men's control, so most women do not think in terms of the male body being for the taking. Admire, yes; take, no.

As yet in photography, we have only men viewing women's bodies as sex objects. There have been a few isolated examples of photographs by women of nude men. And there have been few photographs of men photographed by men as sexually attractive, or women photographed by women. But it will surely come. Some claim that women will not objectify bodies, but that is unlikely if the object of attention is the body, not the person. By separating someone's sex from him or her, there is the risk of denying his or her humanity and wholeness.

The third myth, that of glamour portrait, also involves desire, but in a less overtly sexual, more refined way. Glamour portraits of women do not have the same effect on women as they do on men. If fascination with photographs of other humans lies in their relation to the viewer's self-image, then women can only see the woman in the portrait as a competitor for men's attention. One of the classic glamour portraits is Steichen's "Gloria Swanson." Withdrawn behind her veil, she represents forbidden fruit. Mystery outweighs anything the viewer is told. Even if Ms. Swanson vanishes with the veil, as of course she must, the picture remains as consolation for men. Women are merely competing with an illusion, a fiction of the photographer's imagination.

Glamour portraits exist to deny a woman's middle age, and consequently deny men's too. Photography is of course not alone in its neglect of mature women. Women who wish to record middle-aged existence face the further problem of the middle-aged men who are curators, critics, editors, and historians of photography. Photographs of women who are young, nude, stylish, famous, or beautiful are the images which those men are most likely to accept as photographs of Woman. They are not receptive to the idea that an unattractive, plain, weary, middle-aged woman is also Woman. De Beauvoir claims that middle-aged women remind us of our own encroaching age. Thus to deny women's middle years, to remain surrounded by youth, is to deny one's own age.

For a woman attempting to express her sexuality, a trap has been set. If she attempts only to refute the masculine vision, she will make propaganda, not art. Her work will be consumed by her anger. As Virginia Woolf observed, the flaw in the center that has rotted many a woman's art is that "she [has] altered her values in deference to the opinions of others." Rather than reacting against the established standards, she must work from within herself. This doesn't mean that art should be without passion, but passion alone cannot qualify as art. There must be sufficient control in the passion to make the image the artist's own.

The situation for women artists is improving, if not within the photographic community, then among women themselves. Whereas each woman once felt that she was working within a vacuum, with little precedent (Beaumont Newhall mentions only ten women photographers by

name in the seminal *History of Photography*), there is now the opportunity for exchange between contemporaries and an increasing awareness of predecessors. The most publicized views of the women's liberation movement have been those that are negative: the critical, defensive claims of subjection and oppression. Too few of the more positive goals have been acknowledged beyond the movement's own publications, goals which include the re-evaluation of women's historical roles and the consequent rediscovery and recognition of forceful, pioneering women of the past. They also include increasing respect for the intuitive as well as rational powers, and the realization that the old dual system of values in which women's art was judged inferior must be replaced by an awareness that men's art is not inherently better than women's, and that the differences may have more to do with ideas expressed then with the quality of expression.

The effect of this re-orientation is most obvious in the younger women who are experiencing the strength of collective awareness from the beginning of their careers. Although they share many of the same concerns and confront many of the same barriers, Dater and Nettles have not been discussed with the other photographers, mainly because too much has changed within photography and our culture for a direct comparison of the generations born before and after 1940. Wells and Arbus share many of the awarenesses of the current generation—Arbus in the modernity of her approach, Wells in the changes in her life style—but they still remain essentially products of the era in which they were born.

Dater's self-awareness as a woman is evidenced by her choice of projects. She has sought out and portrayed modern women of this decade: women who regard themselves as facts, not symbols, and who resent having their bodies separated from them and reduced to symbols in someone else's reality or merely to an object for attention. As reviewer Kenda North observed, they are women more likely to "consider man a subject to be confronted rather than shyly approached."

For Bea Nettles, being a woman in the traditional sense is beautiful. She prefers the accidental to the rigidly controlled, the dreamed to the factually supported, the passive to the exploited. She expresses her own ego gently without the aggressive intrusion of self into the photograph which delights many men (as, for example, Lee Friedlander does in his *Self Portrait*). Her work is almost purely intuitive, her symbols and visual metaphors often so personal that viewers are excluded from anything beyond sensual delight until a familiarity with her works enables them to recognize the repeated symbols.

The societal changes now occurring are not solely beneficial to women. That they relate to all human life was realized by no less a male chauvinist than Norman Mailer:

> Female liberty is going to be achieved the way every liberty is achieved . . . against the grain, against the paradox of the fact that there is much in human life that forbids liberty . . . the whole question of women's liberation is the deepest question that faces us, and we're gonna go right into the very elements of existence and eternity before we're through. . . .

Of more immediate concern is the necessity for an artist to come to some understanding of the role sex plays in her or his art. The fact of someone's sex does not necessarily dictate attitude, but to ignore the fact of sex in evaluating art may by oversight rob a work of its richness. It is improbable that a man would have undertaken the project "The American Country Woman," and equally improbable that a woman would have made Wingate Paine's book *Mirror of Venus,* in which he states that women "are creatures to be gentled and tamed, and then made wild again." Sexual prejudices and preferences are an important factor in the way any viewer responds to a work of art, especially if the work concerns something sexual; but too often the role of these preferences is overlooked and the ultimate decision of value may be assumed to be of a more objective nature. If women artists are to have real support, the influence of sexual preference in the evaluation of art must be understood.

The relationship between her sex and her art is, then, an important consideration for a woman. Before she can succeed as an artist, she must overcome many social and economic barriers peculiar to women as well as those applicable to all artists. Then, with respect to creative expression, she must understand her femininity through her own experiences, accept it, and then forget that she is a woman, as Virginia Woolf explains, so that her art will be "full of that curious sexual quality which comes only when sex is unconscious of itself." Finally, if she succeeds in clarifying her unique vision, she must be prepared for the neglect, even hostility, of a male-dominated art world.

GERTRUDE KASEBIER

1852-1934

Gertrude Käsebier, who suppressed her desire to be an artist until she was thirty-six and her children almost grown, eventually became one of America's eminent photographers. Born Gertrude Stanton in Iowa in 1852, she attained national and international prominence soon after opening her portrait studio in New York City in 1897. By 1900, her photograph "The Manager" had been sold for $100, which reportedly was the highest price then paid for an art photograph. She entered the competitive field of portrait photography at a time when commercial portraiture was dominated by artificial settings of papier mâché props and painted backdrops and by dull, flat lighting. Amid much criticism, she set out to change these standards by using dramatic direct lighting and more natural, if elegant, settings. After several years of attacking her as a mere amateur, her critics turned around and began to imitate her style of portraiture.

Käsebier's interest in the visual arts began as a child in the rough mining town of Leadville, Colorado. When her father died, she was sent East to live with her maternal grandmother and to attend Moravian Seminary for Girls in Bethlehem, Pennsylvania. Later, she moved to her mother's boarding house in New York, where she met Edward Käsebier, a salesman from Wiesbaden, Germany. They were married in 1873.

Early in the marriage, she applied to Cooper Union, the most noted art school in New York, only to be turned down. By 1888, with her home duties virtually completed, she enrolled at Pratt Institute to study painting, particularly portraiture. In 1907, after she had turned from painting to photography, she explained her passion to be a portraitist:

> I am now a mother and a grandmother, and I do not recall that I have ever ignored the claims of the nomadic button and the ceaseless call for sympathy, and the greatest demand on time and patience. My children and their children have been my closest thought, but from the first days of dawning individuality, I have longed unceasingly to make pictures of people . . . to make likenesses that are biographies, to bring out in each photograph the essential personality that is variously called temperament, soul, humanity.

Just before she entered Pratt she had been given a camera and had become proficient enough to win a $50 first prize in a contest, but her painting professors' and colleagues' disdain of photography as an artistic medium made her put away the camera. In the next five years, she devoted most of her time and energy to painting.

In 1893, she made the first of many trips to Europe for study and travel. Leaving her son with her husband, she took her two daughters to live with relatives in Germany. She said later there was just enough room left in her trunk for her to pack her camera, again against the advice of her associates. One rainy day in the French province where she was staying, when it was impossible to go out and paint, she made several indoor portraits with her camera. Delighted with the results, she realized instinctively that she had found the best medium to express what she had to say. Having thus decided on her true vocation, she set out to master the medium:

> I had no conveniences for work, no darkroom, no running water in the house. Owing to the long twilight, I could not begin developing before ten o'clock. I had to carry my wet plates down to the river Brie to be washed. My way was through a winding path, with a tangle of overhanging branches, through a darkness so dense I could not see a step before me. It was often two o'clock in the morning, or almost dawn, when I had

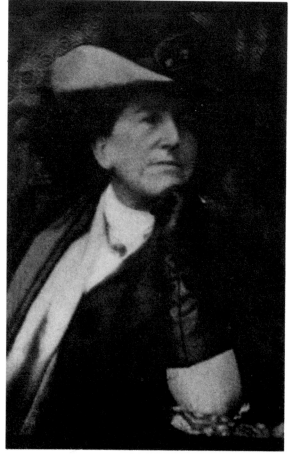

Portrait by Edward Steichen

finished. I could not avoid dragged skirts and wet feet. More than one
friend predicted I would get my death.

Later that summer Käsebier decided that to obtain exactly what she wanted in each
photograph, she needed to know more about the technical aspects of the medium. So
she apprenticed herself to a German chemist who knew photography. A few years
later, when she had decided to open a portrait studio in New York, she apprenticed
herself further for six months to a commercial portraitist in Brooklyn. Although his
approach to photography did not appeal to her, she learned there all the practical
technicalities of operating a portrait studio, from handling large quantities of materials
to bookkeeping.

If Käsebier rejected the artificial trappings and stiff poses of most of her predecessors,
she no less avoided photography's ability to record with infinite detail. The
photographic processes that she used enabled her to obliterate detail and to
emphasize broad areas of light and shade in an impressionistic style very similar to
Whistler's paintings. She was not interested in facts, but rather in sentiment. Her
purpose was not to inform, but to share an experience, to evoke an emotional
response from the viewer. The most factually informative photographs she made were
those portraits done for magazine assignments and the series that she did on the
Indians in Buffalo Bill's Wild West troupe.

Around 1898, Käsebier began a series of photographs on motherhood which were her
most romantic, most intuitively derived images. It is from this series that her two most
frequently reproduced works—"The Manger" and "Blessed Art Thou Among
Women"—emerged. She did not systematically plan the series. Most of the people
included were friends or members of her family whom she happened to be
photographing when the inherent potential for expression in the moment suddenly
struck her. At such times, she would take the photograph, then make a print from the
original negative, and on that print, paint out areas of unnecessary detail to convey
precisely what she felt. She would then photograph the reworked print, using this
negative to make the final print. To the finished print, she gave a title which specified
her idea.

It is the combination of title and image which makes these photographs so revealing to
any sympathetic viewer, or ridiculous to any who insist that photographs
communicate only external reality. To Käsebier, it was not important whether or not
the woman in "The War Widow" had actually lost her husband in a war. What she
wanted the viewer to contemplate was a given situation, in conjunction with all the
implications of the phrase "The War Widow." The relationship between title and
image in some photos is more obvious than in others. Some titles, such as "The
Picture Book," are merely descriptive and do not radically alter the viewer's
interpretation of the photograph. Others, such as "Blessed Art Thou Among Women,"
contribute a perspective perhaps not possible from seeing the photograph untitled. In
such cases, the title and the photograph often act as separate entities, each with its
own meanings and associations which, when brought together, combine to create a
third, separate meaning.

"The Heritage of Motherhood," for instance, is a title capable of evoking various
responses. Without the photograph, these responses would probably center on the
more traditional relationships of a mother's nourishing and protective role toward her

children. But the photograph does not portray this image. In it, a large woman sits, cape or shawl loosely about her shoulders, in a barren, rocky landscape, the whole picture very dark. When the title is applied, suddenly her solitude becomes evident. How can motherhood be implied without the presence of a child? Why is the woman alone in such an environment? It then becomes a personal, atypical approach to motherhood, one born from experience. As reviewer Giles Edgerton (Mary Fenton Roberts was her real name) commented in 1906, "What wild wastes of desolation, what barren paths of mental agony must a woman have trod to reveal to the camera the ghost of radiant motherhood! Ibsen would have written a four-act tragedy from the picture."

Käsebier portrayed both the bitter and the sweet moments in motherhood. Her love of children is expressed in both the commissioned portraits and the family scenes. The children in her photographs are generally innocent and precious, while the mothers with small children are loving and helpful. And yet she was also able to make photographs such as "The Heritage of Motherhood" and another very puzzling photograph entitled "Marriage: Yoked and Muzzled," in which two small children stand hand in hand before two tremendous oxen that are yoked and muzzled. Whether the title is to be taken seriously or ironically is not clear. Käsebier was known for her wit, but also for her candor.

There is no question that Käsebier resented those long years of postponement before she could begin her artistic vocation. She felt, however, that her success could be attributed to the sensibilities she gained through the years of "much suffering, much disappointment, and much renunciation." She felt she had learned to know the world because of what the world had extracted from her. Although her writing mentions her suffering, she revealed few specific causes for it. She only hinted at the constant discouragement from her friends and family, who did not think she should pursue a professional career, and the usual complications of combining a career with home responsibilities. What embittered her severely was the criticism her early photographs provoked.

Strongly influenced by a painter's values, Käsebier departed radically from the accepted methods of photographic portraiture. Her only support came from other photographers who shared her predilection for picturesque images. She was a pioneer in a new school of American photography that included other such notable photographers as Edward Steichen, Alvin Langdon Coburn, Clarence White, and Alfred Stieglitz. Stieglitz became their champion, publishing their photographs first in *Camera Notes* and then in *Camera Work*. He exhibited their photographs at the New York Camera Club and later at his gallery, "291."

At the beginning of this century pictorial photography was widely recognized as the standard for excellence in photography, but by 1910 the art climate had begun to change again. The pictorial style that had been so radical in 1897 was outdated by the new aesthetics from Europe in painting, literature, and photography, all of which emphasized experimental subjects as well as techniques. In 1916, Käsebier, White, and Coburn were among the photographers who sought to perpetuate pictorial ideals by organizing the Pictorial Photographers of America, but the soft-focus subject motifs turned out to be ill-suited for the postwar world of the 1920s. A radical artist had lived to see herself become conservative and unfashionable. She closed her studio in 1929 and died five years later.

Portrait of Clarence White and his mother, c. 1910

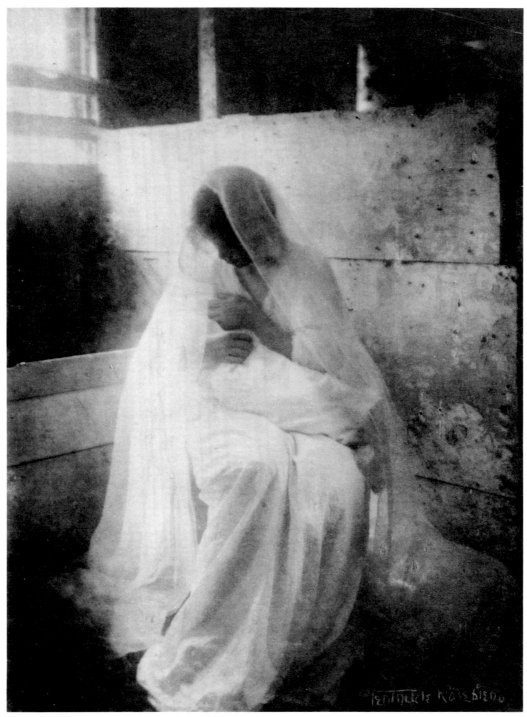

The Manger, 1899

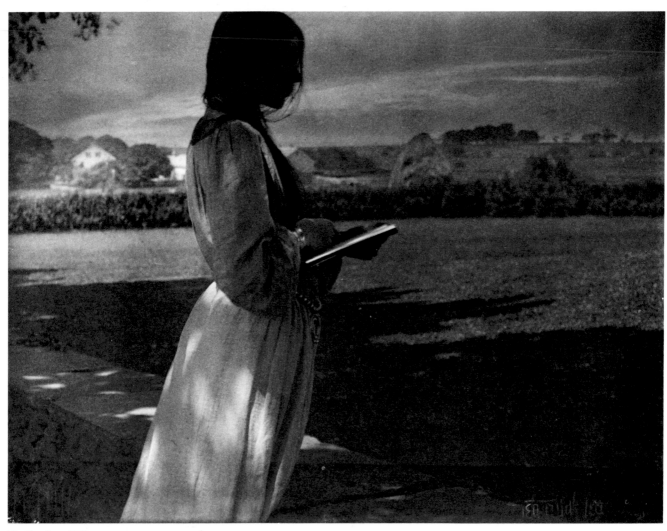

The Sketch, c. 1902

Blessed Art Thou Among Women, 1899

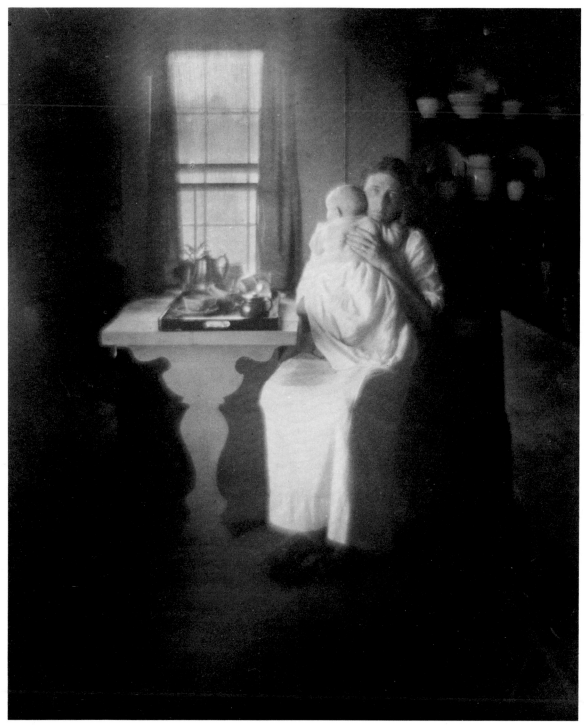

The War Widow (Beatrice Baxter Ruyl)

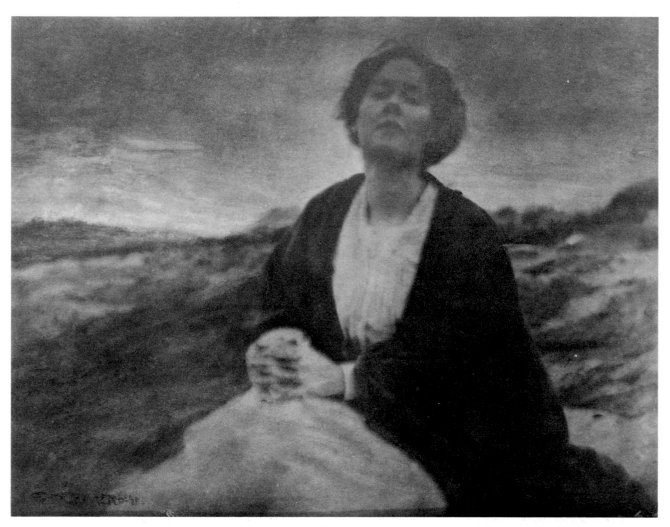

The Heritage of Motherhood, c. 1900

23

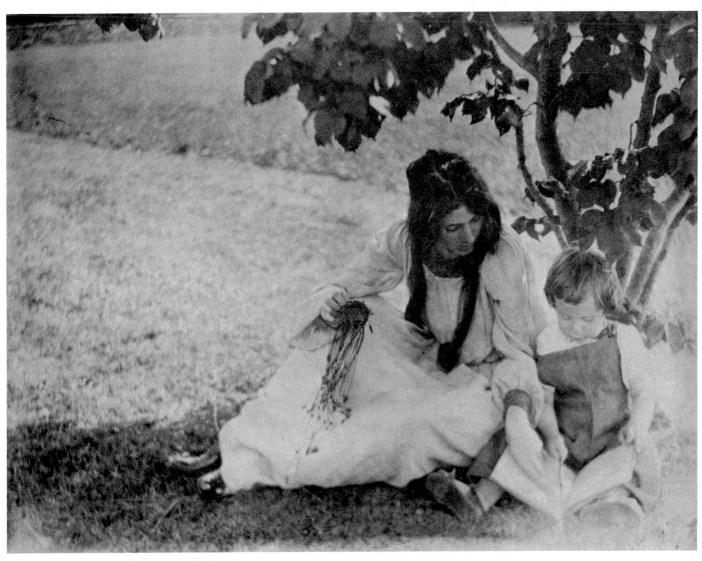

The Picture Book, 1902

Happy Days, 1902

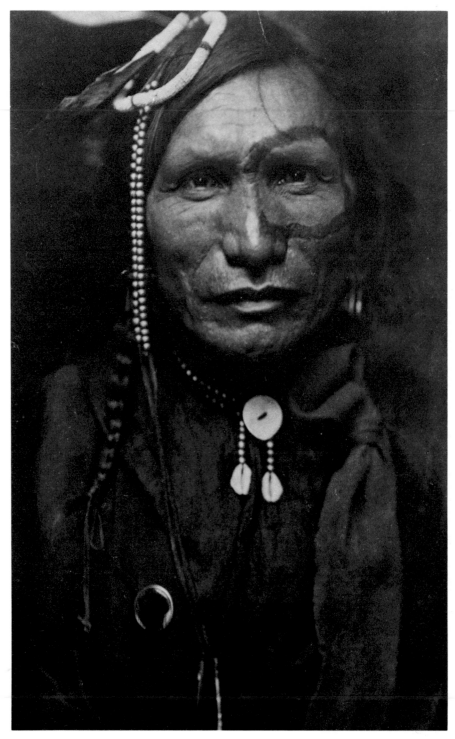

American Indian portrait, c. 1899

Portrait of Sadakichi Hartmann, c. 1910

FRANCES BENJAMIN JOHNSTON
1864-1952

Frances Benjamin Johnston was born in Grafton, West Virginia, and grew up "on the banks of the Ohio River; in Rochester, New York; and Washington, D.C." After high school in Govanston, Maryland, she studied painting and drawing for two years at the Académie Julien in Paris, then continued her studies at the Art Students League in Washington, D.C. At 25, she accepted a job offered by a friend as correspondent to a New York magazine and illustrated her articles with her own drawings. With the half-tone process gaining in popularity, she decided that her articles would be more interesting if they were illustrated by photographs rather than sketches. So, obtaining a new Kodak camera from George Eastman, a family friend, she apprenticed with Dr. T. W. Smillie in the photographic laboratory of the Smithsonian Institution.

The first article illustrated with her own photographs was "Uncle Sam's Money," a two-part series on the United States Mint, which was published in *Demorest's Family Magazine* in December 1889 and January 1890. *Demorest's* published many articles by Johnston over the next three years, often in serial form. They included articles on Pennsylvania coal fields, on the White House, on Mammoth Cave, and on the homes of Congressmen and the Washington diplomatic corps. These pieces were clever and informative; Johnston's accompanying photographs were lucid and rich with detail. As a woman writing for a women's magazine, she included matters typically assumed to be of interest to women: how miners raised their children, the cute remarks of the guide in Mammoth Cave, the duties of the Presidents' wives.

In May 1899, Johnston was commissioned to photograph the Washington, D.C., school system for the Paris Exposition of 1900, and in the next six weeks she made 700 large-format negatives. Not the least of her problems was getting school children to sit still through exposures of up to twenty seconds. At the time, these photographs were considered among her finest and she won one of the three gold medals awarded to American women at the exposition. Also exhibited there, to wide acclaim, were her photographs of the Hampton Institute in Virginia. Photographing the Hampton community and the black families living in the surrounding countryside, she juxtaposed the two groups as life before and after a Hampton education. These photographs were later used by Hampton for fund-raising and publicity, and by Booker T. Washington in several articles on black education.

That summer, Johnston was also commissioned by her agent, George Grantham Bain, to photograph Admiral Dewey on his victorious voyage back from Manila. Johnston was spending the summer in Europe, and Dewey was scheduled to stop in Naples on his way home. Knowing that she would need a letter of introduction to board ship, she turned to an old acquaintance, the then Governor of New York, Theodore Roosevelt. Pressed for time to get to Naples before Dewey, she took a train to Roosevelt's home at Oyster Bay, Long Island, in hopes of securing his assistance. He received her, gave the necessary introduction by writing a message on her calling card, and wished her luck. Her arrival in Naples coincided exactly with Dewey's and not only did she receive permission to photograph him, but also to investigate all phases of life aboard his ship the U.S.S. *Olympia*.

The tremendous drive and determination evidenced by Johnston in this one year were to characterize her long career. She was described as a charming, witty woman, but a bit rebellious because she "drank beer, smoked and daringly showed her ankles."

Like Margaret Bourke-White, Johnston was not oblivious to the commercial advantages of being slightly notorious. Johnston, however, lacked Bourke-White's acute business sense. Although her prices were always competitive with the best in her field, she rarely opened bills and was continuously feuding with the Internal Revenue Service over her income. Although she was a perfectionist about her photographs—quite capable of cutting down a tree that blocked her view of a Williamsburg church—she often missed deadlines. For unknown reasons, she gave her Dewey photographs to a rival photographer to deliver to Bain in New York, and they reached the States several weeks after those of her competitor, to Bain's frustration and anger. There are other complaints from businesses in her files in the Library of Congress, such as the letter from the *Ladies' Home Journal* in 1891 complaining that after selling them exclusive rights to some White House photographs, she then sold these photographs to *Lester's Magazine*.

In the early 1890s she opened a portrait studio in Washington and was soon accepted in Washington circles as an eccentric but charming and competent photographer. Unofficially she became the photographer for every president from Cleveland in his second term to Taft. One of Mrs. Cleveland's first projects was to go with the Cabinet ladies to have their portraits taken by Johnston. After she had established her portrait studio and enjoyed several years as a successful journalist for magazines, she decided to test her skills in the photographic salons then exhibiting the finest in art photography. Her photographs were accepted into the first exhibition that she entered in 1896, and for several years she continued to exhibit in pictorial exhibitions both in America and abroad. She became an out-of-town member of the New York Camera Club, and in an 1899 article, a reviewer referred to her as "the most distinguished of the club's women photographers."

That same year, Johnston and Gertrude Käsebier served together as jurors for the prestigious Philadelphia Salon of pictorial photographers. The two women were friends. They frequently worked for the same magazines, sometimes referring jobs to each other. It seems likely that they also shared the views that Käsebier had expressed in an article in 1898:

> I earnestly advise women of artistic tastes to train for the unworked field of modern photography. It seems to be especially adapted to them and the few who have entered it are meeting with gratifying and profitable success. . . . Besides, consider the advantage of a vocation which necessitates one's being a taking woman.

Johnston, like Käsebier, encouraged other women to become photographers. In 1897, she wrote an article for the *Ladies' Home Journal* entitled "What a Woman Can Do with a Camera," in which she offered much practical advice about equipment, skills, and costs. She also promoted the work of her contemporaries. In 1900, as one of the few women delegates to the International Photographic Congress in Paris, she delivered a talk in fluent French on women photographers of America. The next year, utilizing her Paris talk, she published "The Foremost Women Photographers in America," a series of six articles in the *Ladies' Home Journal*.

The photographs that Johnston entered in pictorialist salons were portraits and scenes with titles like "A Gainsborough Girl," "The Critic," and "They Toil Not, Neither Do They Spin," in a manner very similar to Käsebier's. However, her frank, reportage

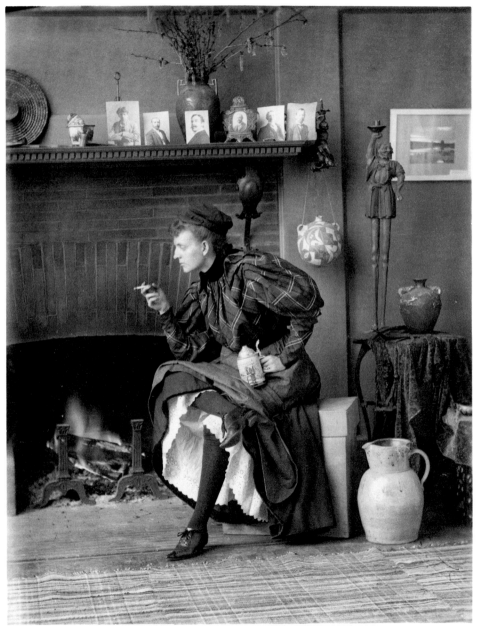

Self-portrait

inclinations were ill suited for the intuitive bent of pictorial photography, and few of these images are interesting today. In only a few years, she gave up exhibiting to return to journalism. There are several references in contemporary pictorial publications to the loss of Johnston to the vulgar popular press.

Sometime after the turn of the century, Johnston accepted into partnership Mattie Edward Hewitt, originally of St. Louis. They decided that architectural photography was open to new talent, so in 1909 they bid successfully on the job of photographing the New Theatre in New York. Once in the city, they began to receive commissions from most of the big architectural firms such as McKim, Mead & White, Grant La Farge, and Goodhue & Ferguson. They also photographed the ''palaces'' and gardens of J. P. Morgan, John Payne Whitney, J. J. Astor, and Mrs. Philip M. Lydig, to name a few of their wealthy customers. Often, the customers were infuriated when Johnston ushered them out of their own homes while she was working.

Johnston was most reticent about her personal life; even in letters to friends and family there are very few references to other friends or to events of personal interest. So it is not known why or how the partnership with Hewitt dissolved. She continued, however, to concentrate on garden photography for several years.

In 1927, at age sixty-three, Johnston was commissioned to photograph the restored historic home of Mrs. Daniel Devore, in Fredericksburg, Virginia. She soon realized that while the homes and early American architecture of the Eastern states had been adequately recorded, there were many fine old buildings in the South soon to be lost without record. She talked Mrs. Devore into commissioning her to photograph the architecture in Fredericksburg, Old Falmouth, and the vicinity. These photographs, exhibited at the Library of Congress in 1929, led to other assignments. In the same year, Johnston published with Henry Irving Brock a book on *Colonial Churches in Virginia,* and sold 156 photographs to the Library of Congress's new department, Pictorial Archives of Early American Architecture. Between 1930 and 1932, she made 1,000 negatives covering sixty-seven of Virginia's 100 counties.

Johnston received in 1933 the first of four consecutive Carnegie Foundation grants amounting to over $26,000. During the following seven years, she made 7,648 negatives of buildings and homes in nine Southern states. Friends joked that she could smell an old home five miles off the highway. Many of the homes she located by sparking the enthusiasm of local community groups. Johnston retired to a quieter life in New Orleans at seventy-six years of age, and five years later was made an honorary member of the American Institute of Architects for her records of early American architecture. In 1948, she gave her negatives, prints, and correspondence to the Library of Congress and four years later died at eighty-eight.

Until *The Hampton Album* was published by the Museum of Modern Art in 1966, hers was virtually a forgotten name. Very little research has been done in the early popular press, so her reportage work was unknown and her other photographs in the pictorial magazines do not compare with the work of Steichen, Stieglitz, or Käsebier. There are many reasons why she is important and should be remembered. Even if her photographs were not as beautiful as they unquestionably are, her careful, expansive documentation of the events and customs of her day would be invaluable to historians.

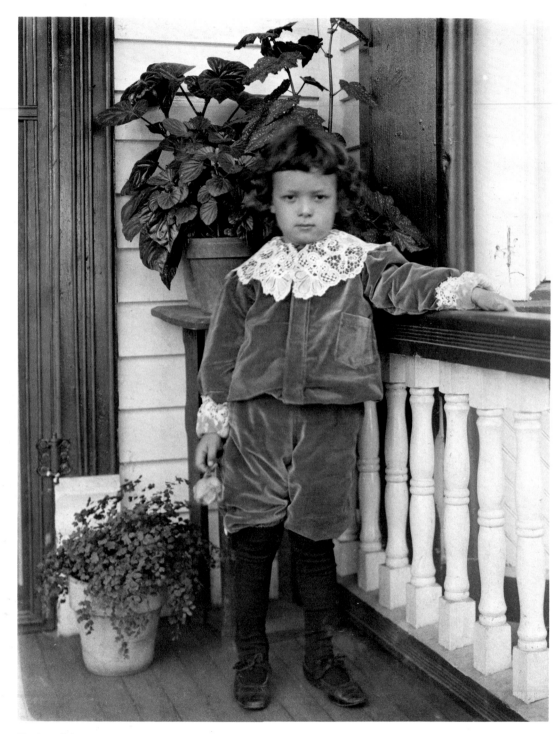

Mrs. Logan's boy

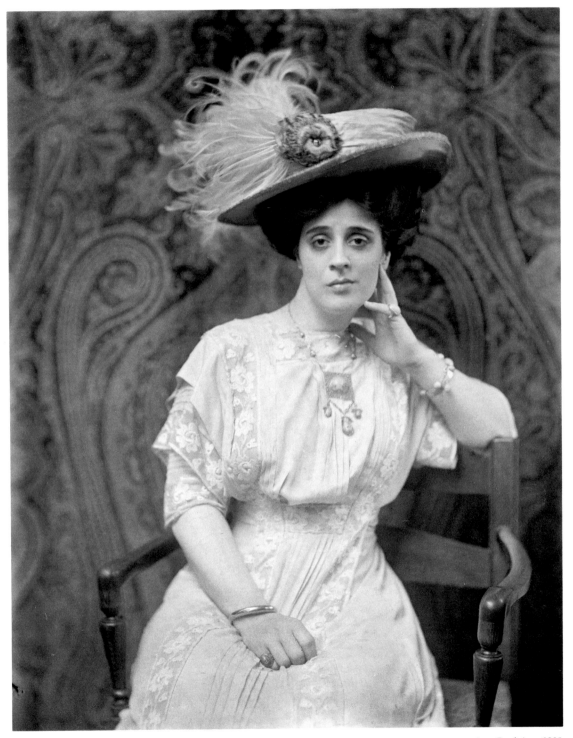

Jane Cowl, June 1908

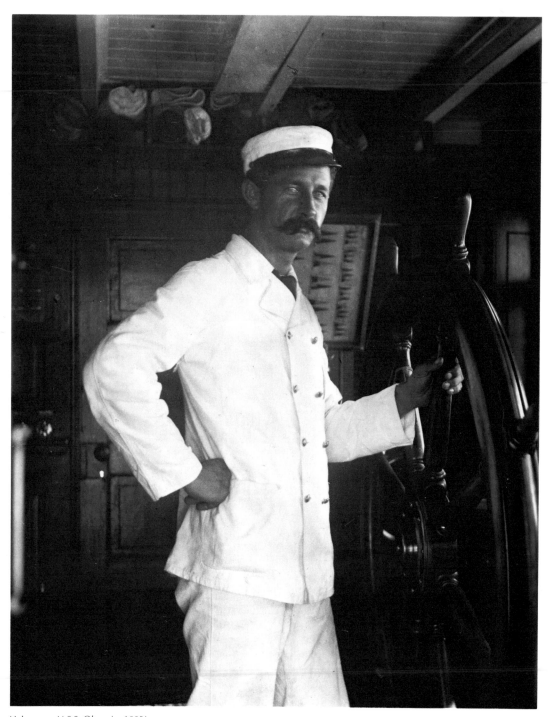

Helmsman, U.S.S. *Olympia*, 1899'

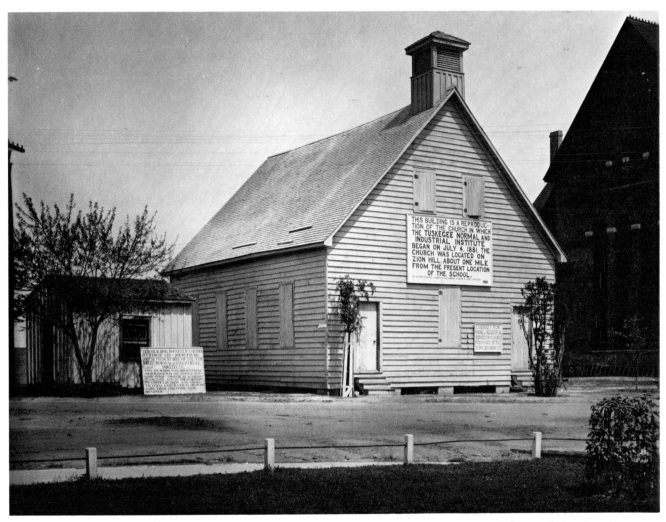

Building in which Tuskegee began, 1902

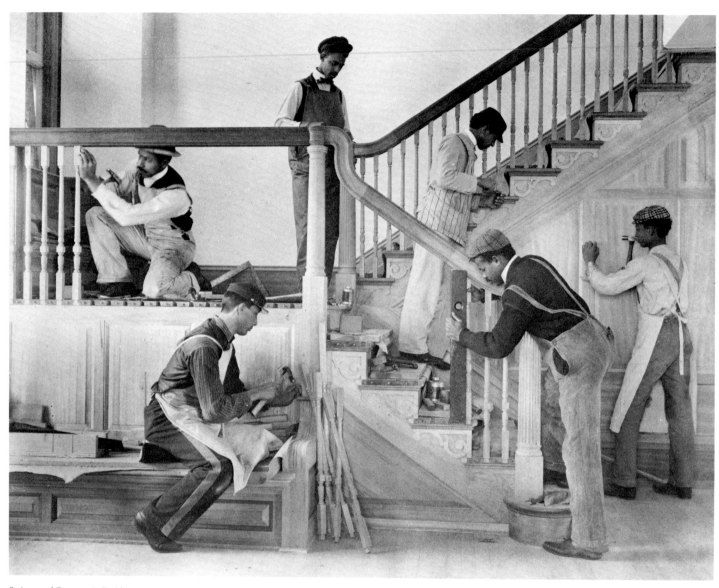

Stairway of Treasurer's Residence, Hampton Institute. Students at work, 1900

Adele Quinney. Stockbridge tribe.

A girl whose every physical measurement is artistically correct, 1900

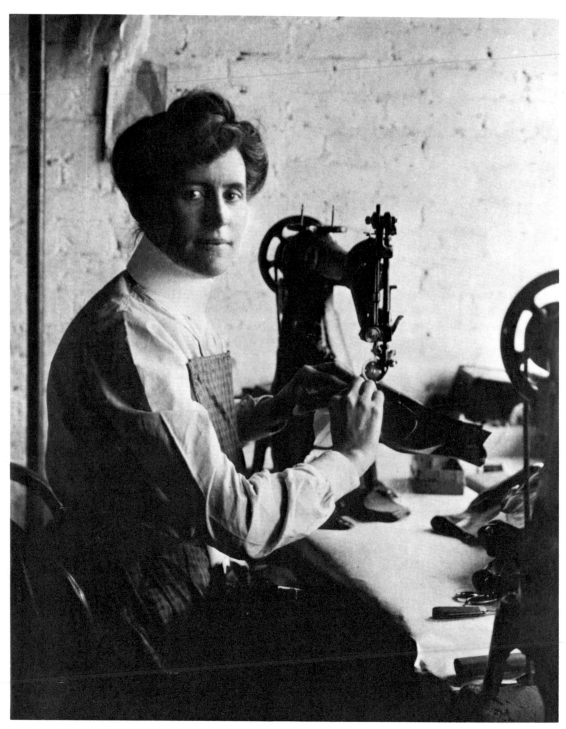

Woman worker in shoe factory, Lynn, Massachusetts, 1895

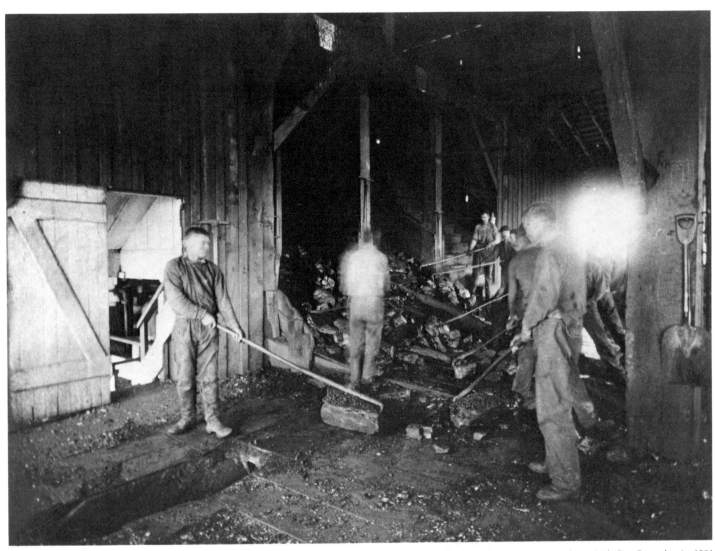

Men Breaking lumps in Kohinoor mine, Shenandoah City, Pennsylvania, 1891

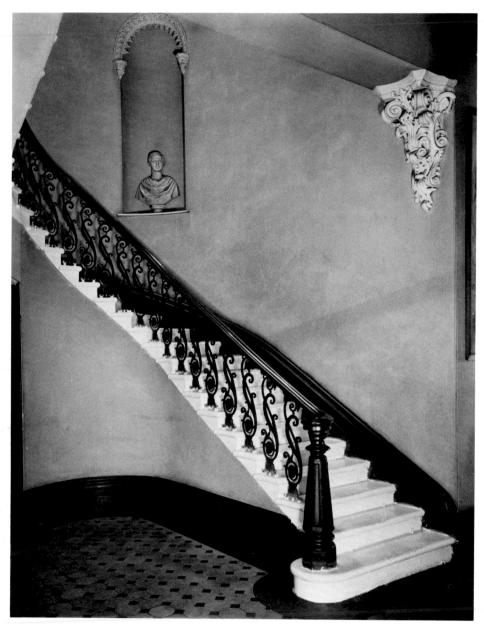

Stairway of Green -Meldrim House, Savannah, Georgia

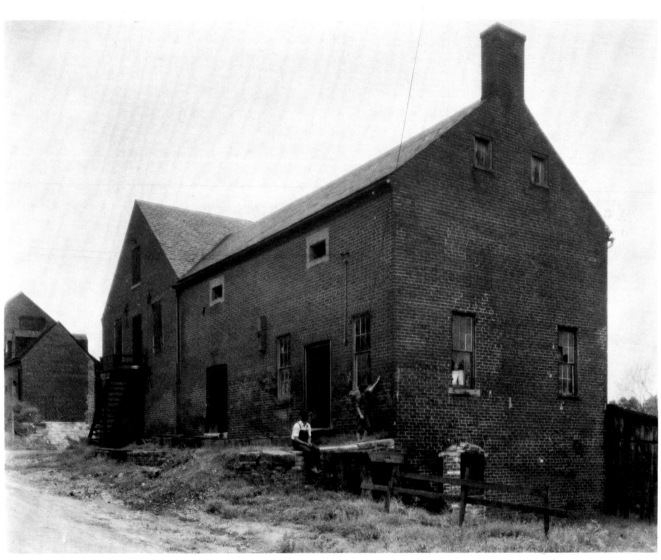

Warehouse, Fredericksburg, Virginia, c. 1928

MARGARET BOURKE-WHITE

1904-1971

Margaret Bourke-White was an ambitious woman whose driving sense of perfection enabled her to become one of the most renowned photographers in America, and to the rest of the world probably the best-known American photographer. Had she been born a man, Bourke-White could scarcely have enjoyed more success. Through her exploits she enabled thousands of Americans to witness world events, and they in return offered her their respect and appreciation.

Bourke-White's popularity is attributable to the quality of her art, to her life style, to her sex, and to her sense of good business. She was a journalist with the talent to be in the right place at the right moment. She had the energy, drive, and courage to get her where she wanted to be and the intelligence to find out the who-what-why of every event she covered. She was the first Western correspondent allowed in Russia after the Revolution and the only Western correspondent there when the Germans invaded in World War II, she was with General Patton when he liberated Buchenwald, and she was only a few blocks from Gandhi when he was assassinated.

Her special ability was to put news in context for people, to isolate that which was important in the values of her generation. For those living through the second quarter of the twentieth century, her photographs evoke their past; for those born after World War II, it is more difficult to become as involved in her imagery. Her photographs reflect the strong intellect that has worked through the significance of what is before her camera. Because many of these photographs seem so impersonal, students often feel the need for captions. Everyone can relate to the prisoners at Buchenwald, to the gold miners baking in their own sweat, and to most of the destitute sharecroppers, but the majority of her photographs leave many young people untouched, especially those students who have no interest in, or knowledge of, history.

It was as historical records that Bourke-White valued her photographs. For her, to photograph was more than a desire to show her world to others, it was a responsibility, a trust. When explaining why she made herself photograph the living dead at Buchenwald and the vulture-torn bodies in Calcutta streets, she wrote:

> Difficult as these things may be to report and to photograph, it is something we war correspondents must do. We are in a privileged and sometimes unhappy position. We see a great deal of the world. Our obligation is to pass it on to others.

It was this deep sense of obligation that helped to keep her constantly moving around the world, that allowed her to make heavy demands on herself and on other people, and that gave her the reputation of never accepting "no" for an answer.

Margaret Bourke-White was born in 1904 to Minnie Bourke and Joe White of New York City. She first studied photography with Clarence White at Columbia University and continued to photograph throughout her college years. After graduation from Cornell University in 1927, she became a freelance photographer in Cleveland, where she had a chance to pursue her fascination with machines and heavy industry. Although "Machine Art" was in vogue among Western artists during the '20s and '30s, Bourke-White's desire to photograph the interiors of factories came largely as a surprise to the Cleveland industrialists. It also made good copy for reporters.

Bourke-White enjoyed the limelight and recognized its value as free advertising and good business. Between 1930 and 1971, at least one newspaper or magazine article

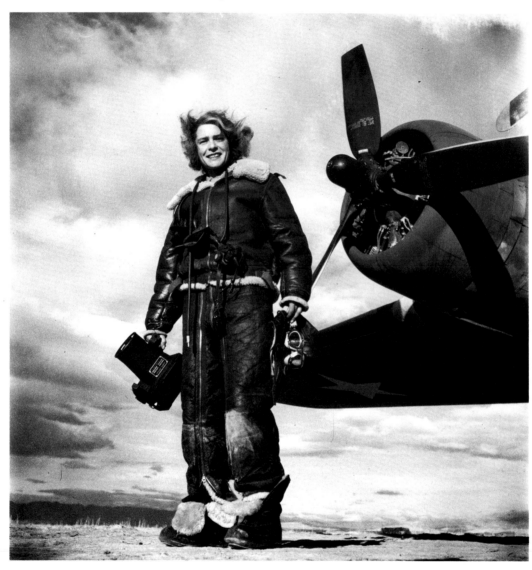

Portrait by Time, Inc.

about her appeared each year, not to mention the dozens of articles that she wrote and those written by others illustrated with her photographs. After each of her major photographic expeditions, she published a book about her adventures. Despite her heavy schedule of magazine assignments, six such books, plus an autobiography and four other books in collaboration with another author, appeared between 1931 and 1963.

In 1929, Bourke-White moved to New York to become the first staff photographer on Henry Luce's new magazine, *Fortune.* She worked six months of the year with *Fortune,* devoting the other six months to advertising assignments. These were financially very successful years, but in 1934 an assignment for *Fortune* brought a dramatic change in her values. She was sent to photograph the droughts in the American Midwest. As she wrote then, the very desperation of the stricken farmers "jolted me into the realization that a man is more than a figure to put into the background of a photograph for scale." Her new human commitment continued when she spent several months recording life in the Southern states with Erskine Caldwell (to whom she was married from 1942 to 1945). Their resultant book, *You Have Seen Their Faces,* published in 1937, received tremendous acclaim both as a new form of journalism, in which word and photograph were equally important, and as a seething indictment of the sharecropping system.

It is impossible to follow Bourke-White's development without understanding her close association with *Life:* she and *Life* operated as a team from 1936, when her photograph of a Montana dam appeared on the cover of the first issue, to 1957, when Parkinson's disease forced her to stop photographing. In supplying the equipment, the connections, and the vital form, *Life* was her straight man, and she its artistic star. She brought to *Life* the same dedication and high standards that went into the making of every Bourke-White essay, as well as her credo that "to understand another human being you must gain some insight into the conditions which made him what he is." She wanted to show the magazine's solidly middle-class readers the similarities, not the differences, in people. Like a child that can provoke pleasant conversation between strangers, she wished to make everyone weep and smile together, and she was loved for it.

During the *Life* years, she covered both the Italian and German fronts of World War II, the agony of partition in India and Pakistan, and the guerrilla armies of the Korean War. She published such exposés as "Mayor Frank Hague and His Jersey City" in 1938, and several on South Africa in 1950. In her single-minded concentration on getting the photograph she wanted, she stayed out of bomb shelters during air raids; she slept in muddy trenches and learned to bathe out of her helmet; she survived a torpedoed ship, a helicopter crash, a street riot, and a flash flood. As she once explained, "If anybody gets in my way when I am making a picture, I become irrational. I'm never sure what I am going to do, or sometimes even aware of what I do—only that I want that picture."

It was Bourke-White's aggressiveness as well as her success that provoked keen hostility among fellow photographers. On assignments some found her "unbearable,"

even "bitchy." She didn't hesitate to give orders and had no patience for anyone who got in her way, even though she could be very charming when she wanted to use her femininity to her advantage.

She was a good-looking woman whose attractiveness improved with maturity, and her taste in clothes was stylish. In the early days in Cleveland, she owned only one gray suit, but with it she wore either a red hat and red gloves, or a blue hat with blue gloves, and she kept track of which outfit she had worn to which assignment on which day. She used a blue velvet focusing cloth for the camera to go with the blue outfit and a black velvet cloth for the red. In New York, when she could afford them, she attached great importance to appropriate costumes for each day, even to the extent of changing her clothes in a taxi en route from one assignment to another. She wore pants suits long before they were fashionable. She had her hair and her nails done weekly whenever the job permitted.

Bourke-White was also aware of herself as a woman when considering other women. The right of women to work as equals with men was integral to her political philosophy. In all of her books, she discussed women's working conditions, noting, for example, with delight that the women of India and Pakistan were "breaking out of their ancient bondage, leaving seclusion to take an active part in the life of these new nations." In her introduction to *U.S.S.R. Photographs* (1934) she observed:

> What makes Soviet Russia the new land of the machine are the new social relations of the men and women around the machine. The new man . . . and with him, on an equal footing, the new woman—operating drill presses, studying medicine and engineering—are integral parts of a people working collectively toward a common goal.

Bourke-White naturally was not amazed when a woman did anything well (although she did not hesitate to take advantage of this reaction in other people for the sake of her own publicity), but she did believe there were different sensibilities within the two sexes. In her autobiography she wrote about a woman who had risen to be a *Life* film editor:

> Usually I object when someone makes overmuch of men's work vs. women's work, for I think it is the excellence of the results which counts. And yet, truly this [selection of best prints] is a woman's job—this supersensitive "feel" for what the photographer was after, even though he might be half the world away.

In her own work Bourke-White strove to sharpen what she regarded as her feminine awareness of situations. Like Gertrude Käsebier, she felt that personal suffering had helped to develop this perception. After the end of a painful first marriage she had written:

> Now that I was facing life again as an individual, I made a great discovery. . . . I had lived through the loneliness and the anguish. It was as though everything that could really be hard in my life had been packed into those two short years, and nothing would ever seem so hard again.

From the dissolution of this marriage until she began her courageous fight against Parkinson's disease in the early 1950s, her primary concern was her job, and the cost of this dedication was solitude.

It was not that I was against marriage, despite my initial unhappy experience. But . . . I had picked a life that dealt with excitement, tragedy, mass calamities, human triumphs and human suffering. To throw my whole self into recording and attempting to understand these things I needed an inner serenity as a kind of balance. This was something I could not have if I was torn apart for fear of hurting someone every time an assignment of this kind came up.

What made Bourke-White remarkable was this unswerving dedication to the life she had chosen for herself and her talent for following it. The effect of having to give up photography years before her death can only be guessed at, but she struggled against the slowly paralyzing effects of Parkinson's disease with the same courage she had shown in pursuing her unique photographs.

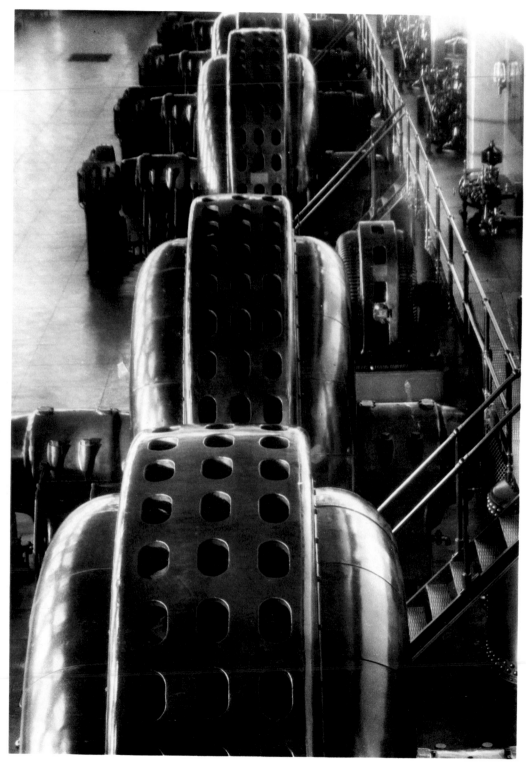

Hydro generators. Niagara Falls Power Company, 1928

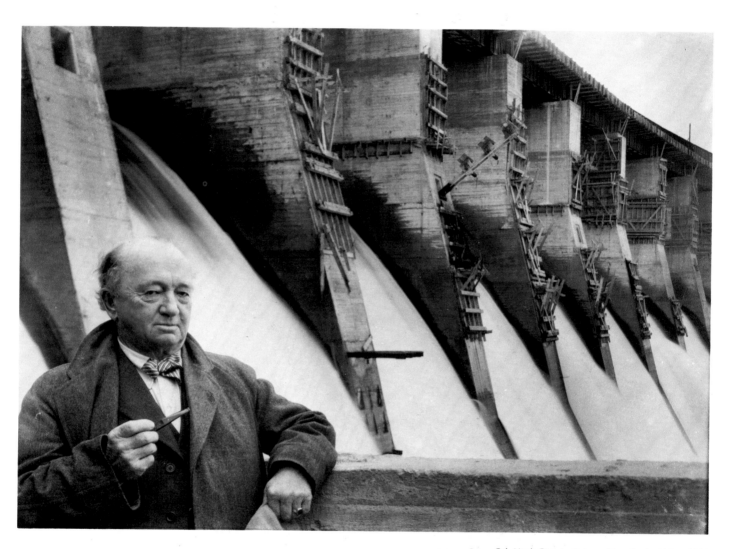

Col. Hugh Cooper, Dnieper Dam, Soviet Union, 1930

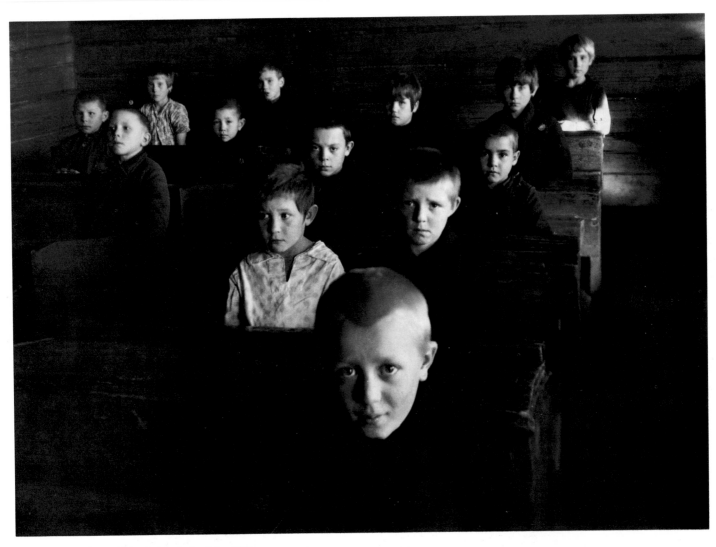

Village school, Kolomna, Volga Region, Soviet Union, 1932

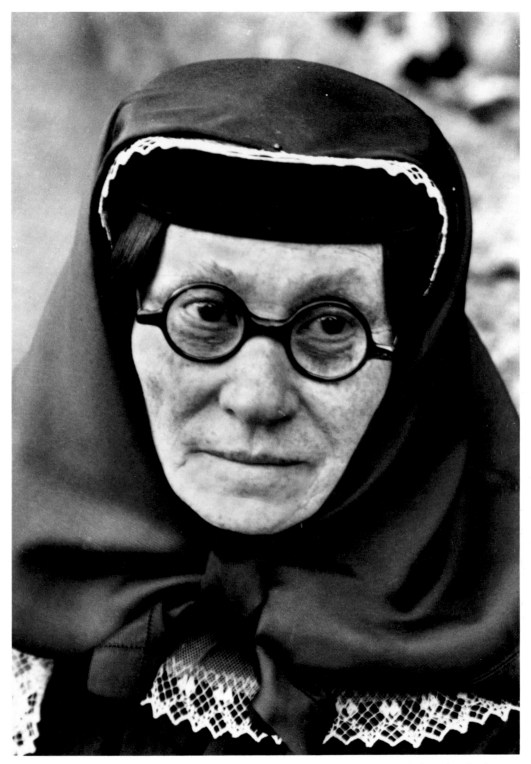

Ekaterina Dzhugashvili: Mother of Stalin, 1932

53

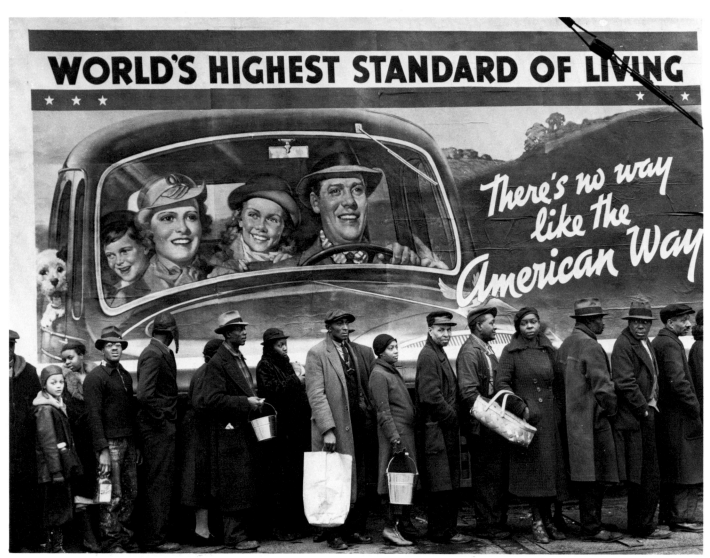

At the time of the Louisville flood, 1937

54

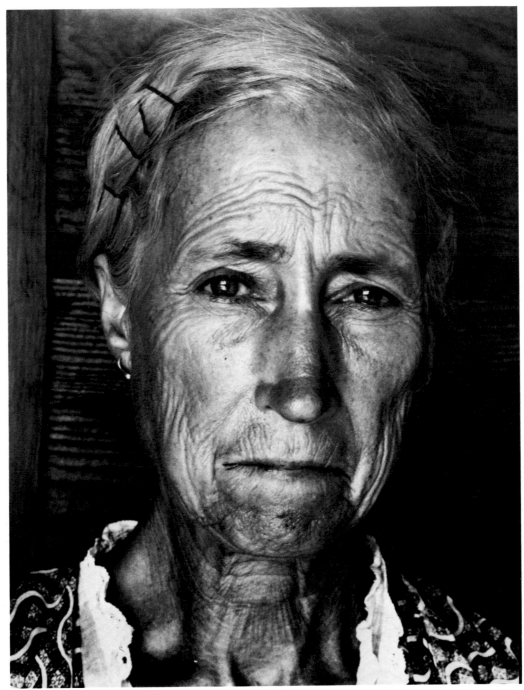

Locket, Georgia, 1936

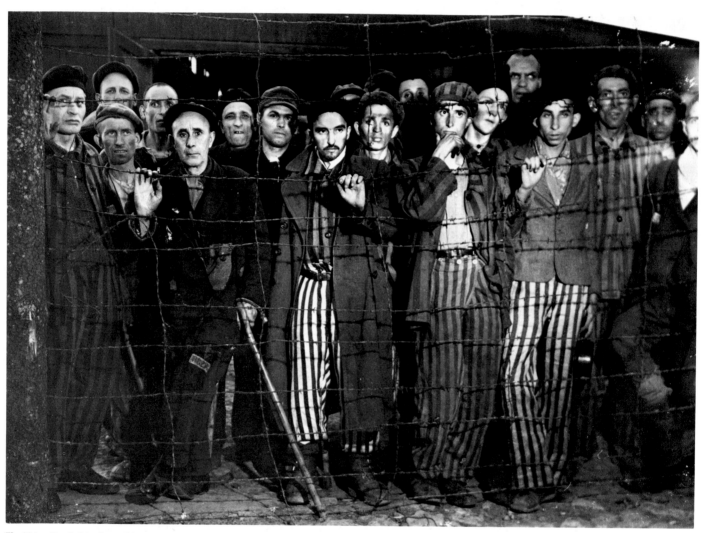

The Living Dead of Buchenwald, April 1945

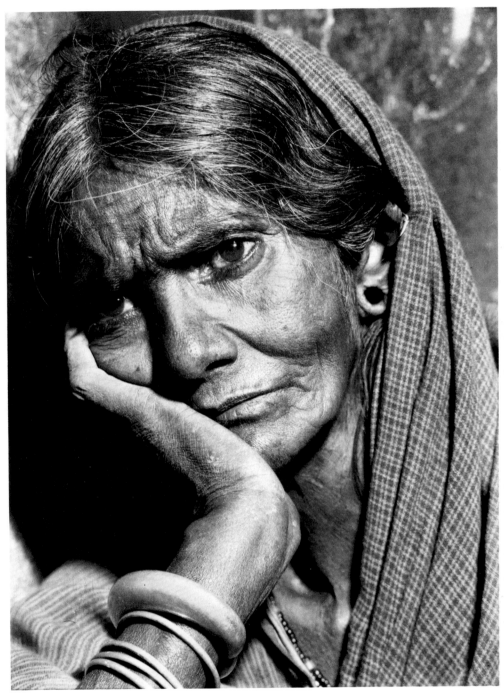

Death's tentative mark, India, 1947

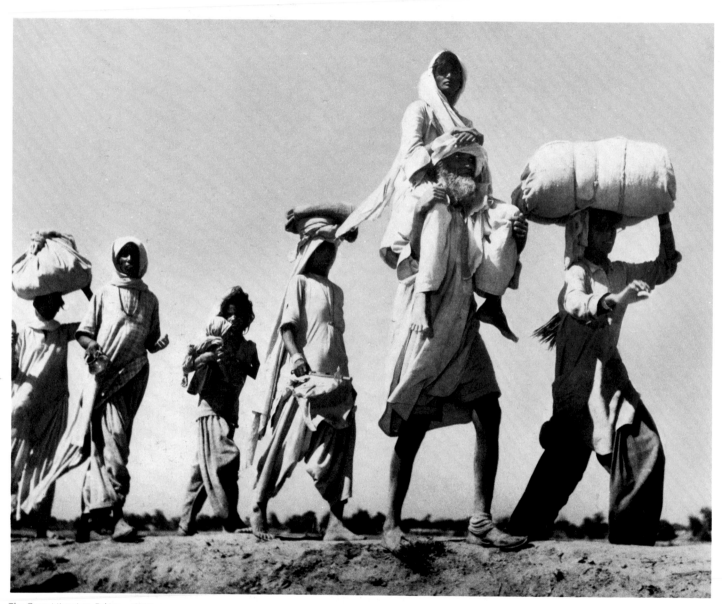

The Great Migration, Pakistan, 1947

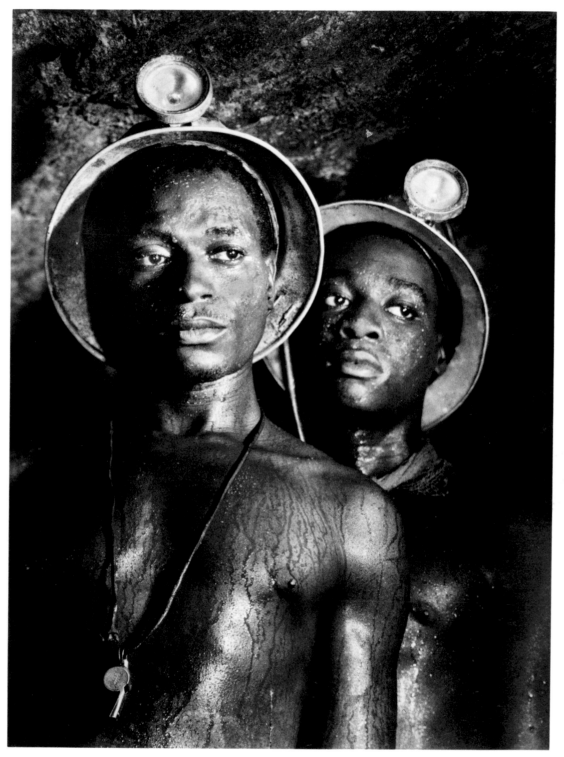

Gold miners, Nos. 1139 & 5122, Johannesburg, South Africa, 1950

DOROTHEA LANGE
1895 - 1965

In 1931, Dorothea Lange, a 36-year-old mother of two, had "a spiritual experience," as she termed it, that changed her life and affected hundreds of other people. It was not a religious or a philosophical revelation, nor even a particularly unique one; it was an insight into her inner being, which presented new artistic direction. The other people affected were not her followers in an institutional sense, but all those who were to be spiritually and intellectually enriched by her photographs. ". . . what I had to do was take pictures and concentrate upon people, only people, all kinds of people, people who paid me and people who didn't." She felt that she needed this change after almost twelve years as a commercial portraitist with her own successful studio in downtown San Francisco. When people paid to be photographed, they came dressed in their finest, expecting the photographer to achieve flattering results. Studio photographs, Lange felt, isolated people from any meaningful context; so, taking her camera into the streets, she found and photographed people who were the economic antithesis of all her wealthy clients. She sought out the destitute, the troubled, the unemployed—not to exploit them but to expose their exploitation by others. As her son Daniel Dixon was to explain later, ugliness and horror were not the subject of her photographs; the subjects were "the people to whom ugliness and horror have happened." "Her attention," he continued, "is not given to the misery but to the miserable. Her concern is not with the affliction but with the afflicted."

The artistic success that Lange enjoyed after 1934 was long in coming. She had first studied photography in 1915 with Arnold Genthe in New York, who had a studio on Fifth Avenue. He had encouraged her, even given her a camera, and had advised her to take a basic photography course with Clarence White at Columbia University. After studying with White, Lange felt sufficiently confident of her skills to take off with a friend on a trip around the world. They left with only $140 and Lange's determination to work along the way as a photographer, but the trip ended abruptly in 1918, when a pickpocket in San Francisco left them only five dollars. Lange decided to stay in California. First she got a job as a photofinisher, then opened her own studio in 1919.

A year later she married the painter Maynard Dixon. It was on their summer trips through the Southwest that she started to photograph outside of her studio. These portraits, like those taken commercially, were at close range, often including only the subject's face without relation to his situation. Few of these portraits were of the quality of Lange's later work—the best of which she deemed "second lookers" because the photographs withstood, even required, a second look by the viewer. In these, Lange moved back from the figure to include something of his/her world: the overburdened car, the bare room, the children clinging insecurely to their mother's clothes. She began to notice the silent language of body gesture and to portray the objects and institutions which symbolized the human quality of their existence. By the 1930s she was interested in the social conflicts and natural disasters disrupting the country, but only as they translated into human experience. She realized, as Anne Morrow Lindbergh recently wrote, "suffering . . . no matter how multiplied . . . is always individual."

In 1934, Willard Van Dyke exhibited her San Francisco street pictures at his studio and wrote a very perceptive article in *Camera Craft* magazine. One of those who saw the exhibition was Paul S. Taylor, an economics professor at the University of California. He decided to use one photograph in an article; then later, as Field Director for the California State Emergency Relief Administration, he hired Lange to photograph

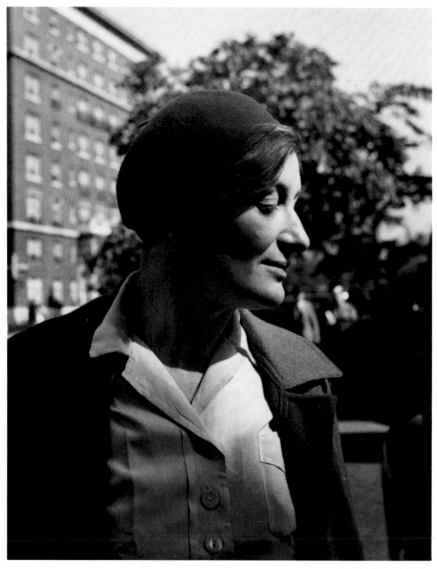

Portrait by Paul Schuster Taylor

62

the migratory agricultural workers. Lange responded very positively to her new job. Country people, she found, shared her sense of values more than people from the city. Over the years, she was to become increasingly critical of the touted values of progress and deeply respected the quiet, simple dignity of people "who have leaned against the wind, and worked in the sun and owned their own land." One difference in her new job was noticeable immediately. "I had begun to talk to the people I photographed," she said. "For some reason, I don't know why, the people in the city were silent people, and we never spoke to each other. But in the migrant camps, there were always talkers. This was very helpful to me, and I think it was helpful to them. It gave us a chance to meet on common ground—something a photographer like myself must find if he's going to do good work."

Taylor, quick to notice that her ear was as good as her eye, incorporated in his reports many of the terse sayings she had recorded. As filmmaker Pare Lorentz observed,

> . . . all the government research departments put together haven't as clear a record of this great migration as is contained in the brief statements of her people. Here are not only the faces of people; here is the metrical, simple, bitter language of a people.

> "I come from Texas and I don't own or owe a thin dime back there."

> "That year the spring come and found us blank."

> "I've wrote back that we're well . . . but I never have wrote we live in a tent."

In the summer of 1935, Lange transferred to Roy E. Stryker's unit of the Resettlement Administration, which later became the Farm Security Administration in the Department of Agriculture. The F.S.A. photographers were to document specific problems in a way which would make them believable to the public, thus arousing public support for government programs. In the seven years that the project lasted, thirteen photographers produced some 270,000 negatives. Lange's work for the F.S.A. took her to every part of the country except New England; in one summer alone she put 17,000 miles on her speedometer.

Also in 1935, Lange had divorced Maynard Dixon to marry Paul Taylor and, when not on specific assignment with the F.S.A., she continued to work with Taylor. In 1939, they published *An American Exodus: A Record of Human Erosion,* a culmination of her F.S.A. work and of their work together since 1934. As the introduction explained: "All photographs, with the few exceptions indicated, were taken by Dorothea Lange. Responsibility for the text rests with Paul Taylor. Beyond that, our work is a product of cooperation in every aspect from the form of the whole to the least detail of arrangement or phrase." The book was a bold experiment in combining words and pictures with equal emphasis, similar in intent to *You Have Seen Their Faces* by Margaret Bourke-White and Erskine Caldwell. But in *An American Exodus,* as the authors were careful to explain, all of the remarks quoted were actually made by the person to whom they were attributed. Bourke-White and Caldwell had been criticized for using fictitious statements, which weakened the book's impact. Taylor and Lange did not want to diffuse the issues. They wanted the book to be provocative because the message was true; they wanted to shock the conscience of the nation into action.

Soon after *An American Exodus* was published, Lange's association with the F.S.A. ended. In 1942 she was again called into government service to photograph the relocation from the California coast, and internment, of 110,000 persons of Japanese ancestry. Lange photographed the Japanese as they dismantled their homes, as they were processed into centers, and finally their conversion of abandoned barracks into new homes. She also photographed the often racially hysterical communities that had forced them out. In the Japanese, she found the same enduring spirit she had valued in the homeless farmers of the Depression, and as with the "Okies," she captured their plight through the faces of the individuals most affected.

In 1941, Lange had received a Guggenheim Fellowship to photograph "the American social scene," but she resigned soon after Pearl Harbor. She worked for the War Relocation Authority for a year, then with the Office of War Information until 1945. Doctors warned her to work less but she ignored their advice, and while photographing the United Nations Conference in San Francisco, she collapsed. The next six years of enforced inactivity were very introspective ones for Lange, from which she derived two new directions. She began to investigate photographs used in sequence; then she started "to photograph the familiar." Instead of photographing people in relation to drastic events, Lange began to photograph people in relation to one another and to their immediate environment. To Lange, an object's value was not necessarily measurable by its uniqueness or its monetary worth, but in time and energy invested, hopes and failures involved. She felt that for too long the daily relationships had been taken for granted "not only by our eyes, but often, by our hearts as well."

In 1954, Lange went to Ireland with her son Daniel Dixon, now a reporter, on assignment for *Life*. During 1958–59, she accompanied Paul Taylor on a trip to Asia; in 1960, to Venezuela and Ecuador; then in 1962, to Egypt. Because she was used to photographing the intimate and the familiar, she felt ill at ease photographing foreign peoples. As she wrote to Nancy Newhall in 1962, "I go because Paul's work takes him there. For my own work I would choose to stay in my own country." Despite her discomfort, or perhaps because of it, the photographs from these trips are some of her finest. She may not have understood what was before her camera as she did at home, but her sense of human experience and love of body gesture overcame all else.

One of her last projects was her sequence on the American country woman, published posthumously in 1966. In the book were two introductory passages by Lange which best explain her theme:

> These photographs were made over a time period of twenty-five years—between the mid-thirties and the mid-fifties, with a single exception. They were made in widely separated sections of the United States. Accompanying most of these portraits is a second photograph which describes the home or environment in which the women lived. . . .

> These are women of the American soil. They are a hardy stock. They are the roots of our country. They inhabit our plains, our prairies, our deserts, our mountains, our valleys and our country towns.

> They are not our well-advertised women of beauty and fashion, nor are they a part of the well-advertised American style of living. These women

represent a different mode of life. They are *of themselves* a very great American style. They live with courage and purpose, a part of our tradition.

As Oakland curator Therese Heyman commented in an exhibition wall label, "The daily demands of existence were pressing and continuous for most of these women, and they did not step back to consider themselves in their roles as women." Lange had started this series long before there was any concerted movement to redefine the role of American women, and it is hard to guess how she would have responded to the Movement. Although she wrote so little about herself as a woman, she would probably have responded favorably to at least some of the changes. Lange had commented that as a young woman she had few women friends. "I think I didn't do the things they did. I didn't have the outlook they had. I've always had a certain kind of drive . . . I had something I could call my trade. . . ." A year before she died, she summed up her vision of the special role of a woman artist, saying that compared to a man's work there was a sharp difference, a gulf. "The women's role is immeasurably more complicated. There are not very many first-class women producers, not many. . . . They produce in other ways. Where they do both there is conflict." As both a mother and artist, Lange certainly understood the conflict. In *The American Country Woman* she was attempting to acknowledge all the women who had produced in other ways.

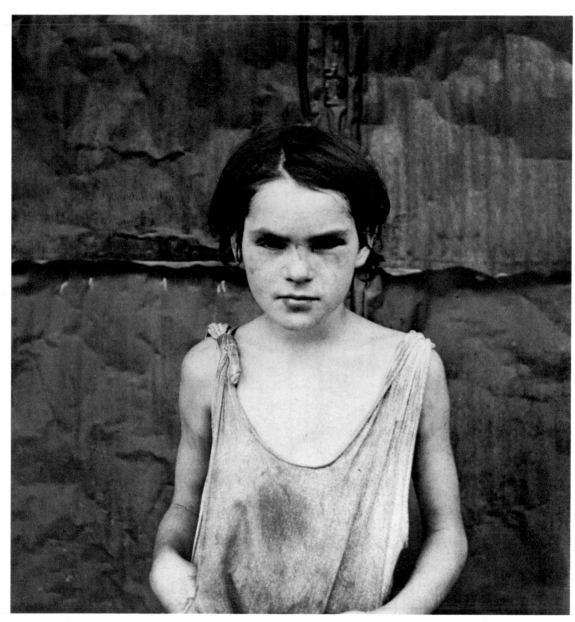

Damaged child, Shacktown, Elm Grove, Oklahoma, 1936

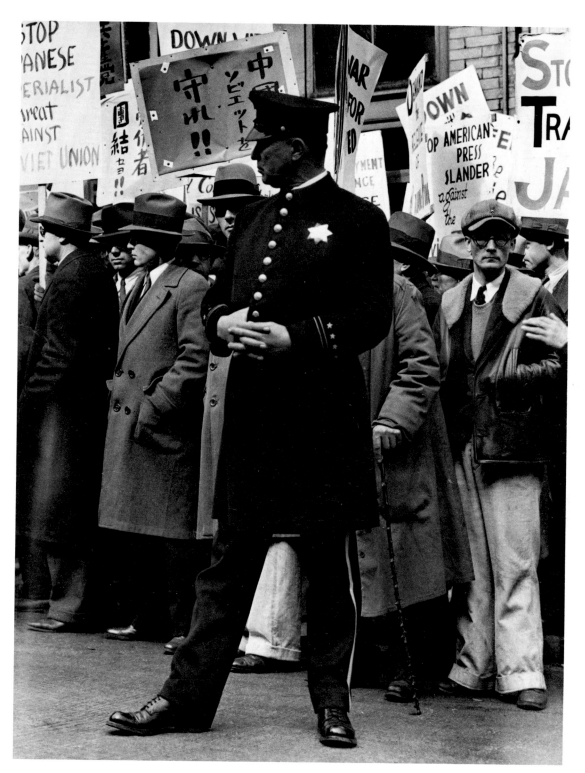

Street demonstration, San Francisco, 1933

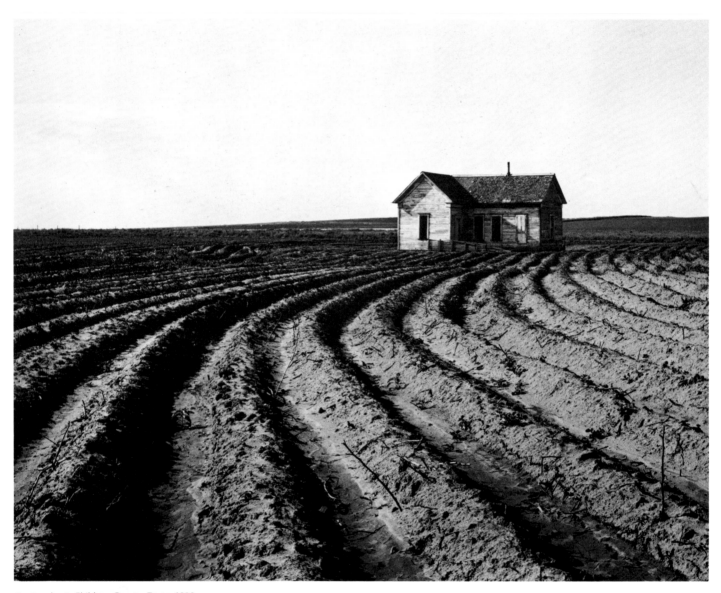

Tractored out, Childress County, Texas, 1938

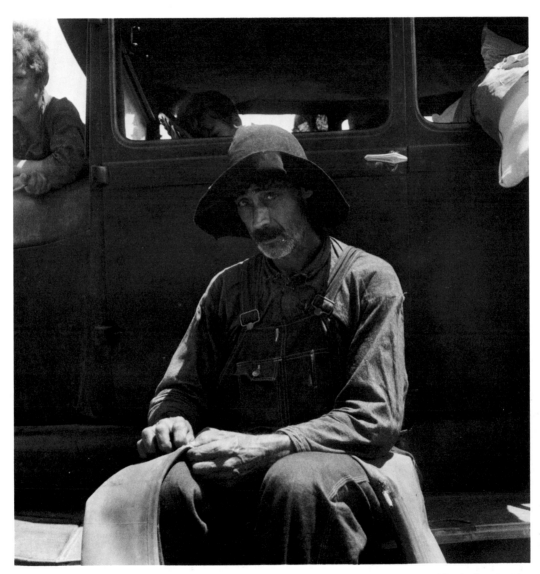

Sharecropper and family, Georgia, 1938

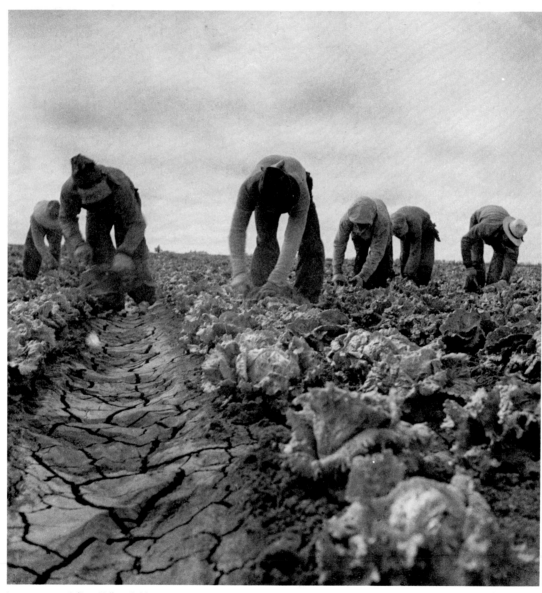

Lettuce cutters, Salinas Valley, California, 1935

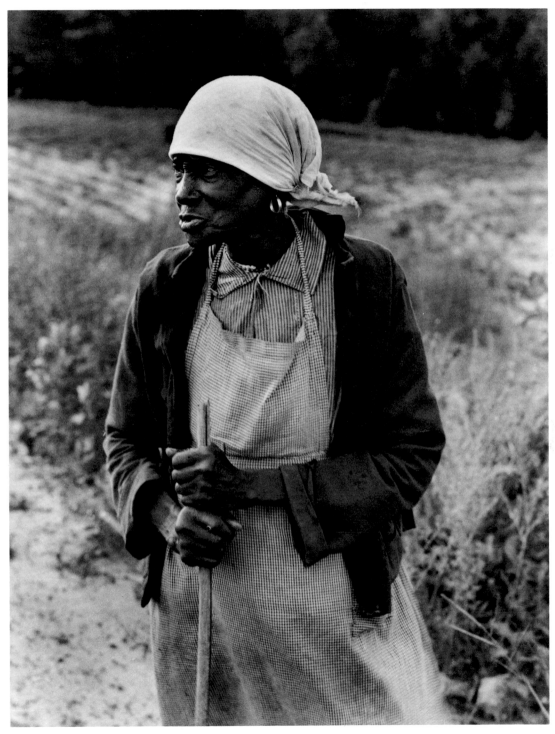

Ex-slave with a long memory, Alabama, 1937

Gunlock, Utah, 1953

Berryessa Valley, California, 1956

Irish child, County Clare, Ireland, 1954

Woman in purdah, Upper Egypt, 1963

BERENICE ABBOTT
1898-

It was in 1921 that Berenice Abbott arrived in Paris, 23 years old and seeking the freedom for artistic fulfillment she had been unable to find in America. Born in Springfield, Ohio, she had resisted her mother's insistence that she teach; she wanted to be a journalist. After a couple of semesters at Ohio State University, she left for New York City, where she lived for three years. Then, as she put it later, "I went to Europe because I had to." First she studied drawing and sculpture with Emile Bourdelle in Paris, then went to Berlin's prestigious Kunstschule. In 1923, her money ran out and she became an assistant to Man Ray, the surrealist painter and photographer. After a three-year apprenticeship, she opened her own professional portrait studio, where she photographed many of the artistic and literary vanguard that made Paris what it was in the twenties—Gide, Cocteau, Joyce, Laurencin, Duchamp, and Ernst, among others.

Two characteristics mark Berenice Abbott's career: her fascination with the changing external world and her single-minded dedication to photography. In a unique way her Parisian portraits preserve some leading personalities of a major twentieth-century era. Making more than mere records, Abbott elicited from her sitters an attitude or trait, which she convincingly portrayed, not without a certain wit, and always with intelligence, sympathy, and respect. She knew that in honestly conveying what was before her camera, she was preserving something essential to our understanding of an era, something which if unrecorded, would be lost. As she later wrote, "The photographer's punctilio is his recognition of the now—to see it so clearly that he looks through it to the past and senses the future. This is a big order and demands wisdom as well as understanding of one's time. Thus the photographer is the contemporary being par excellence; through his eyes the now becomes past."

Abbott's commitment to photography became an integral part of her life very early. One of her first acts was to purchase the prints and negatives of the then unacknowledged genius who photographed Paris and its environs—Eugène Atget. She had first seen his work while working with Man Ray in 1925. Struck by the untarnished photographic sense of Atget's images, she purchased some of his photographs and later asked him to pose for her. From his death in 1927, until the Museum of Modern Art purchased the collection from her in 1968, she preserved the collection and promoted Atget's work through various articles, exhibitions, and books.

In 1929, on a visit to New York, Abbott was struck with a passion to record New York—a city very different from Paris—"not so much beauty and tradition as native fantasia emerging from accelerated greed." "If I had never left America," she said, "I would never have wanted to photograph New York. But when I saw it with fresh eyes, I knew it was *my* country, something I had to set down in photographs. I wanted to record it before it changed completely. Before the old buildings and historic spots were destroyed." In the thirties, New York was a city undergoing rapid change. Skyscrapers were creating man-made canyons which physically dwarfed the men who conceived and built them. Tall buildings were replacing the ethnic neighborhoods where pushcarts crowded the streets and merchandise spilled out on the sidewalks from specialty stores. Abbott was interested in all the activity—old and new, skyscrapers and local industry, Greenwich Village brownstone and Brooklyn tenement.

At first, Abbott could not find anyone to support her self-assigned project. The Depression absorbed her resources and sapped her strength. American indifference

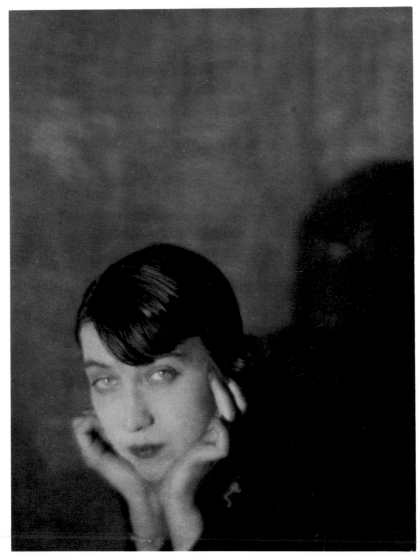

Portrait by Man Ray

was disheartening, especially after the acclaim that her work had begun to receive in Paris. Taking on freelance assignments for magazines, she photographed the city on her own time, and at her own expense. By 1935, she had begun to teach at the New School for Social Research (a steady job yielding steady income) and her New York photographs were exhibited at the Museum of the City of New York. She offered to photograph New York for the Federal Arts Project; this provided her with materials, assistants, and gasoline for the car she needed to carry around her bulky camera and cases. With their support, she continued to photograph the city for the next three years, the project culminating in her book, *Changing New York,* with a text by Elizabeth McCausland.

Abbott felt that working for the W.P.A. had "knocked New York out of me." Her interest shifted to explaining scientific principles through photography. She wanted to do a book on electricity but again was denied the necessary financial support. Although she tried to proceed on her own as she had done with her New York project, the expenses proved prohibitive. The wall of indifference was thicker than it had been when she had wanted to photograph New York. Finally, almost twenty years later, she tried again to explore physics with her camera and obtained a job with the Physical Science Study Commission of Educational Services, Inc. Working in Boston from 1958 to 1961, she often obtained these photographs with improvised equipment of her own devising. Some of the techniques that she applied were ones she had perfected years before when there was no practical need for a solution, just her own curiosity and interest.

Abbott was not a woman who shied away from photography's technical aspects. She wrote two technical books—*A Guide to Better Photography* (1941) and *The View Camera Made Simple* (1948)—the former republished as *New Guide to Better Photography* (1953). She also wrote many articles offering practical advice and raising questions about possible improvements for designers and manufacturers of photographic equipment and supplies.

In 1968, she left New York to move to Maine. That year she also published *A Portrait of Maine.* During her years in New York, Abbott had given her time, her energy, and her art generously to preserve and perpetuate that which she felt was the best in photography. She was an outspoken critic of the pictorialist and of those she referred to as "precious printmakers;" she despised art that "was by the few, for the few." What she actively supported was documentary photography, which she defined as "realistic, objective—the more realistic the better."

Beyond the many one-woman exhibitions she held, Abbott helped to organize, and served as a juror for, exhibitions of the work of younger photographers. She also participated in symposiums, including one in 1940 sponsored by the Institute of Women's Professional Relations to evaluate the opportunities in the field for women. Abbott encouraged women to enter the photography field, bypassing the subject of uniquely feminine handicaps, but she has since admitted that "some annoyances and a lot of silly nonsense" could be very trying, and there were more serious handicaps, such as being paid less than men even for very difficult jobs. She also commented sadly on the number of promising and talented women who studied with her but gave up photography when they married.

A very real comparison can be made between Abbott's work and that of the nineteenth-century photographers who explored the American frontier. She covered New York as systematically as Eadweard Muybridge had explored Yosemite Valley seventy years before. In the best landscape tradition, she proved a faithful witness, returning to favorite spots at different times of the day and in different seasons to record the subtle changes of light and atmosphere and the dramatic ones of growth and decay. In his book *The Photographer and the American Landscape,* John Szarkowski described the task of landscape photographers: "They have peeled away, layer by layer, the dry wrapper of habitual seeing, and have presented new discoveries concerning the structure, the beauty and the meaning of our habitat." This is a very apt description of Abbott's perceptions as long as one remembers her fascination with the complex, seething tempo of the city as well as its actual structure.

Documentary projects generally require mobility and a tremendous amount of concentrated physical and mental stamina, which make them difficult for most women to consider, certainly for women with home responsibilities. As Abbott explained, "Anyone who undertakes such a project must be absolutely dedicated to it." And Berenice Abbott possessed both the mobility and the singular dedication to her work that are prerequisite for such tasks. A further stimulus in her work was provided by friends—poets, writers, painters,and photographers, many as distinguished in their fields as Abbott was in her own. Among them was the brilliant art critic Elizabeth McCausland, one of the few to actively follow photographic events during the 1930s and 1940s. In Berenice Abbott, McCausland rightly acknowledged an artist whose active support of photography's development matched her realistic passion for documentation.

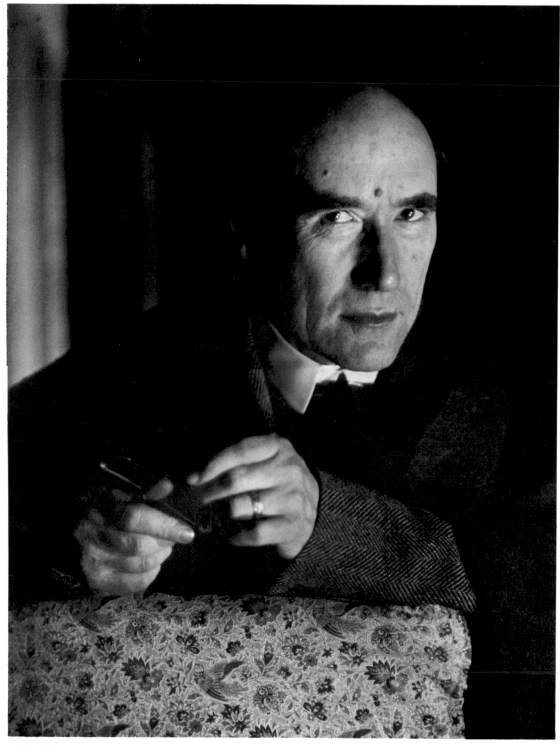

André Gide

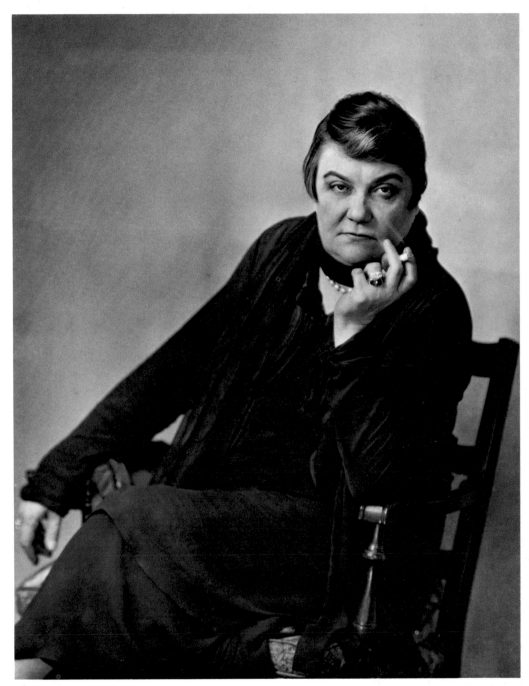

Princess Eugène Murat

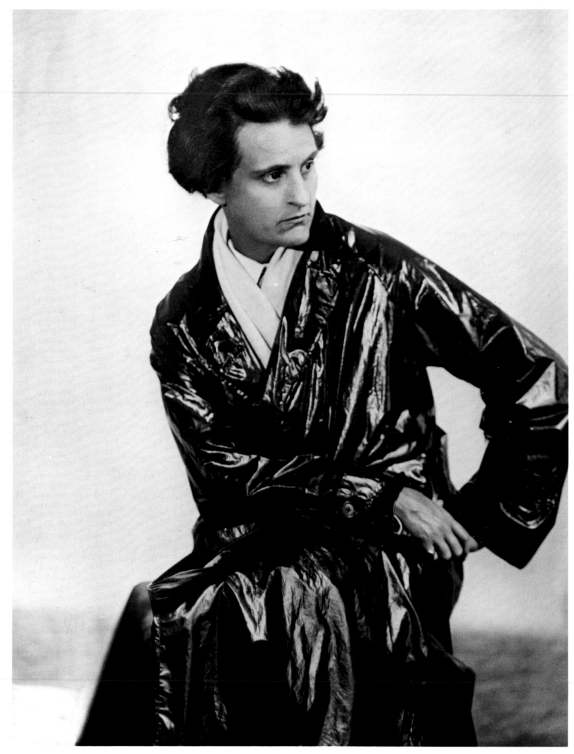

Sylvia Beach

Hands of Jean Cocteau

Daily News Building, New York City

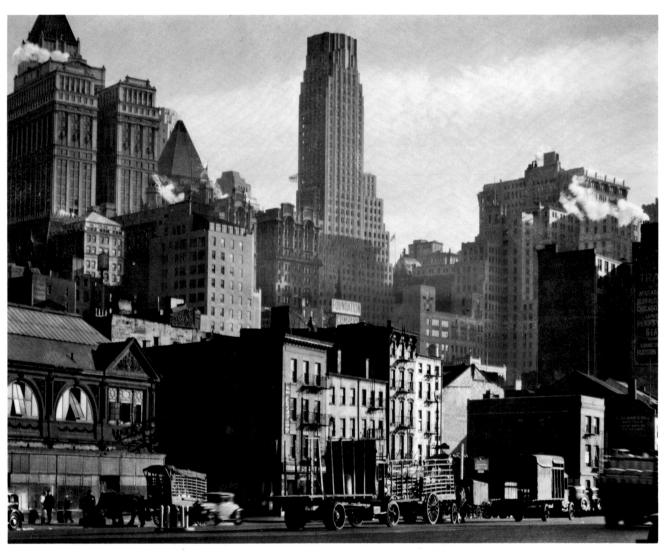

West Street, New York City

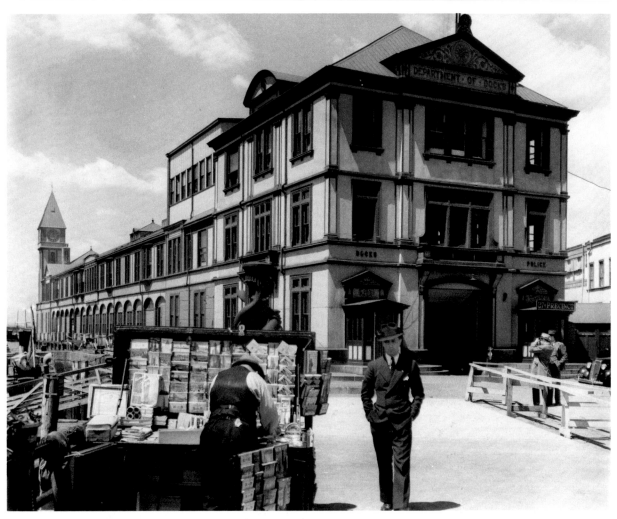

Department of Docks, New York City

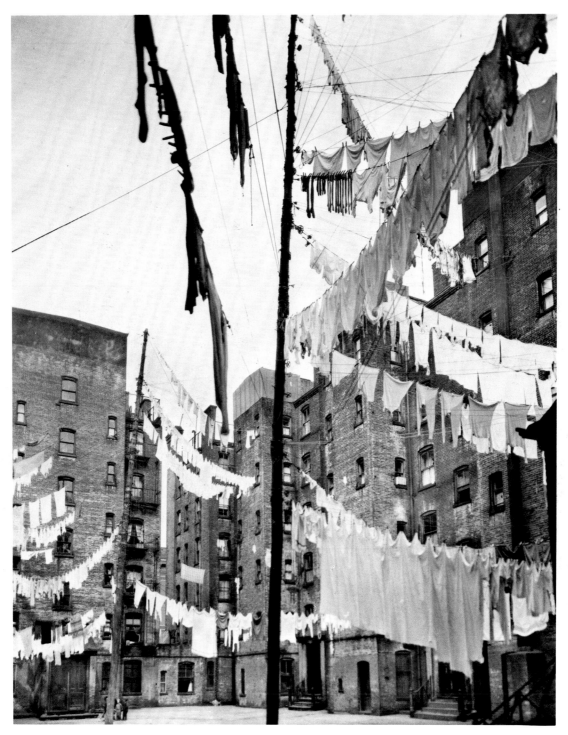

Courtyard of model early tenement, East 70s, New York City

Multiple exposure of a swinging ball in an elliptical orbit

Parabolic mirror, made of many small sections, reflecting one eye

BARBARA MORGAN
1900-

Barbara Morgan was only four when she first declared her intention to be an artist. According to the "Born Genius" premise of art historical writing, this is a natural beginning: great artists are born, not made. In that tradition artists are born with a mysterious essence called Genius or Talent, which, as feminist art historian Linda Nochlin explained, "like murder, must always out, no matter how unlikely or unpromising the circumstances." From that moment when the artist recognizes his or her destiny, all else in the artist's life is subordinated to this mysteriously endowed, motivating force, which ultimately triumphs—not always within the artist's own lifetime. Barbara Morgan was certainly born with the inclination to create, but many a born artist would not have been equal to the difficulties she overcame; as Simone de Beauvoir observed, "One is not born a genius, one becomes a genius." "Becoming" includes mastering the techniques of an artistic medium and developing the sensibility and logic that are integral to interpretive expression. Of those born with talent, few become artists and fewer still, good artists.

Contrary to the mythical being who is born in full bloom, Barbara Morgan has earned her artistic status, generously acknowledging those events and tasks along the way which influenced her direction. From her first declaration, her family encouraged her to paint, to be curious, and to investigate. Her father introduced her to the rhythms of the natural world by reading her articles from *Scientific American*. "Everything," he explained, "is made of dancing atoms . . . the whole world and everything in it is whirling and dancing." He taught her to sit, looking at her fingers, an apple, a chair—"Try to imagine the atoms whirling in each thing." He explained metabolism to her, saying, "In the overview nothing is static; all is in flux."

Raised in California, she became an art student at UCLA, where she was exposed to Oriental philosophy. The ancient Chinese concept of "rhythmic vitality"—the essence of life force—particularly impressed her. It readily related to her father's dancing atoms. Later, as a continuing student of philosophy and primitive cultures, she began to formulate her own impressions about life's rhythms. These concerns with rhythm, motion, dynamism, and harmony, all pivotal to her work, have served to unify the diverse subjects of her art. Her experience with painting (from earliest childhood), her introduction to Eastern philosophies, her mastery of several graphic media, her experiences with stage lighting and puppetry, and finally her introduction to photography through her husband all formed the prelude to her mature art.

In 1925, she joined the art faculty of UCLA, teaching principally basic design, and soon thereafter married Willard D. Morgan, a freelance writer and photographer. Each summer, they traveled through the Southwest. While he photographed for future articles, she painted, or sometimes helped him to photograph. Of those summers she retained two strong and lasting impressions: the land of the Southwest, "those primordially eroded strata of red sandstone, sculptured by grinding earth pressures, wind and water," which engendered a sense of man's negligible role in earth's history, and the American Indian cultures, which revealed a way in which man could accommodate to these forces. "The Navajo and Pueblo Indian tribes who danced their rituals . . . as partners in the cosmic process, attuned me to the universally primal—rather than to either the 'primitive' or the 'civilized.' " She felt that "the stratification of Grand Canyon and Monument Valley attuned me to geologic time; Mesa Verde Cliff Dwellings to ancient human time."

Portrait by Willard Morgan

When Willard Morgan was offered a job in 1930 with E. Leitz, Inc., publicizing the Leica camera, they moved to New York. The transcendent glimpses of life preserved from her Southwestern summers were hard to retain when she was confronted by "the anthropocentric, machine-smothered, self-obsessed, high-decibel, smog-belts of a metropolis," but Morgan continued to paint. In 1932, her first son was born. Two years later, her first one-woman show was exhibited at the Mellon Gallery in Philadelphia. In 1935 her second son was born. Painting became difficult as the responsibilities of motherhood robbed her of precious daylight hours. She was further upset when she read in Isadora Duncan's biography that the famous dancer's children had died in the care of a nursemaid while Duncan was away. There was no question, Morgan decided, but that her children came first.

Since their marriage, Willard had been trying to persuade her to take photography more seriously. For him it was a major art form; in fact, he believed that it was the "real" Modern Art of the twentieth century. At first she had felt that photography was useful only for creating visual records, but in 1925, she had helped the then unknown Edward Weston mount his photography show at UCLA. Although his subject matter was realistic, his composition conveyed symbolic insight; she realized he was capable of making essence visible through photography, that photography could be art. Seeking a way to reconcile her roles as mother and artist, she became a serious photographer. She worked at night when the children were asleep or Willard was home to help care for them. In the medium of black and white film artificial light was as acceptable as daylight.

The transition was facilitated by her idea to produce a book. She had seen Martha Graham perform and responded strongly. Graham's choreography of this period derived chiefly from the Indian and Spanish Southwest, the Frontier, and Puritan New England—sources very close to Morgan's own roots. Barbara Morgan proposed to do a book on Graham's work, and Graham agreed. The book evolved over several years. Slowly, after watching many performances and rehearsals, she extracted gestures and movements which epitomized each dance's concept. The photographs were made in her studio or in the theater (never during actual performances). She worked closely with the dancers, seeking those physical gestures which best conveyed the emotional and spiritual experience of the dance. Morgan wrote about her photographs of the dance, *Letter to the World,* Graham's interpretation of the life of Emily Dickinson:

> The photograph referred to as KICK symbolizes the agony of Emily's life after she has given up her tragic love affair. The second picture in the sequence, SWIRL, was shot at a slower speed for a more relaxed feeling. In the first picture she is horizontal: now she is vertical. She's beginning to transcend that agony; she's no longer as burdened. I had her hand go off into the darkness at an oblique, vertical angle to show that Emily had risen out of her personal life and was arriving at the detached state of a poet. But there's also a twist in the form, indicating that she's not altogether released.

The resulting book, *Martha Graham: Sixteen Dances in Photographs,* was completely designed by Morgan—layout, headings, and typography.

While continuing work on the Graham book, Morgan created visual metaphors with photomontage. Her impressions of New York were too complex to express in a single

image. Strata of people, of places, mood, and meaning were best expressed for her through photomontage. More inventive and imaginative a process than straight photography, this was more congenial to her intuitive approach and it utilized her talent for design. She continues to feel that "as the life style of the Space Age grows more inter-disciplinary, it will be harder for the 'one-track' mind to survive, and the photomontage will be increasingly necessary. I see simultaneous intake, multiple-awareness, and synthesized-comprehension as inevitable, long before the year 2000 A.D."

In a recent interview, Morgan described herself as "living a photomontage," particularly when the children were young and everything had to be fitted workably "into the pattern of the *unexpected, that is* expected when 'raising children.' " To cope with the task she developed a Three Channel System: Channel I, family and home; Channel II, creative work; Channel III, friends, community responsibilities, and life in general. Every night she wrote down the next day's three-way agenda, attempting to anticipate what was required for each. She worked out the system so that mentally she could carry on each channel simultaneously, not having one area invade the other. When she walked into the studio, she felt free to let go.

Like Lange, Morgan has shown in her art the human links binding people. Dance is one thing that all peoples share, love for children is another. Morgan's second photographic book was *Summer's Children: A Photographic Cycle of Life at Camp.* As Peter Bunnell explained in his introduction to her monograph:

> This book, prepared in the late forties and 'conceived as an affirmation of the art and science of human relationships . . .' is deceptively simple. At first viewing it appears to be about what children do at camp, but with reflection it may be seen that these are photographs of experiences, not of events . . . In other words, she was attempting to show the evolving, quiet, yet profoundly moving and sometimes difficult process of human growth.

Morgan's initial motivation for doing this book was her response to the news that the Germans were burning the Jewish ghetto in Warsaw. She had been photographing children's activities at Camp Treetops for years, but when she heard the dreadful radio announcement against the background of children's laughter, she decided to preserve their positive summer experience as a statement of courage and hope. She still feels that too many artists contribute only to bitterness, defeatism, and hate in their art, and that more time should be given to the good things of life, not just the dramatic and sensational.

Books and magazines have been a constant interest for Morgan since college. After her first two books, she designed, wrote, and produced a monograph issue of her work for *Aperture* (1964). In his prefatory remarks, Minor White observed, "How wonderful to behold a person who has developed all of these capacities because of her practice of living as a whole being. A special significance belongs to her code phrase, 'total living.' " Total living also included working as unofficial consultant for her husband's publishing activities. Morgan & Lester Publishing produced its first book in 1935, simultaneous with the birth of Lloyd Morgan. Barbara still retains this position for the company now run by her two sons. It was Morgan & Morgan who produced her most recent work, *Barbara Morgan: Monograph* (1972).

Now she is working on a book to be titled *The Dynamics of Composition*. In it she hopes to convey the essence of her photographic vision. "I am trying to make a consummation of my lifetime love and absorption of all of these practical and very theoretical relationships. It has to do with linkage between the aesthetics and the technical controls that any photographer wants to encompass and bring into fulfillment."

Martha Graham, *Extasis* (Torsol), 1935

Martha Graham, *Letter to the World* (Kick), 1940

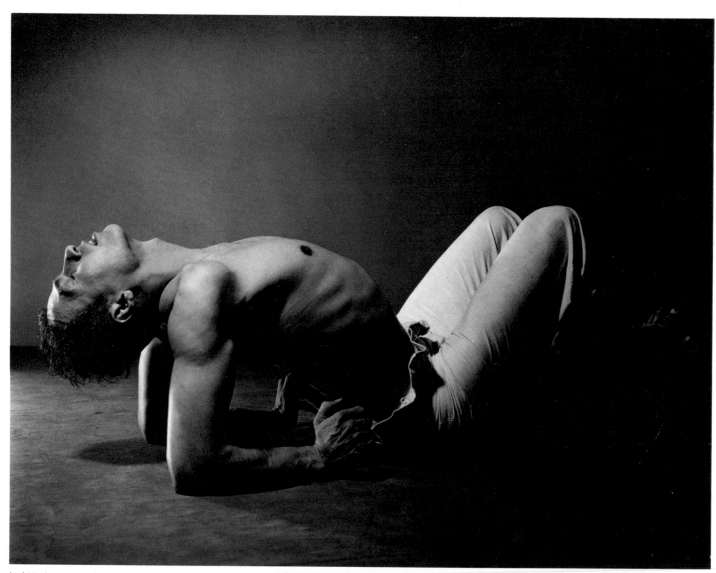

José Limón, *Mexican Suite* (Peon), 1944

Samadhi (light drawing), 1940

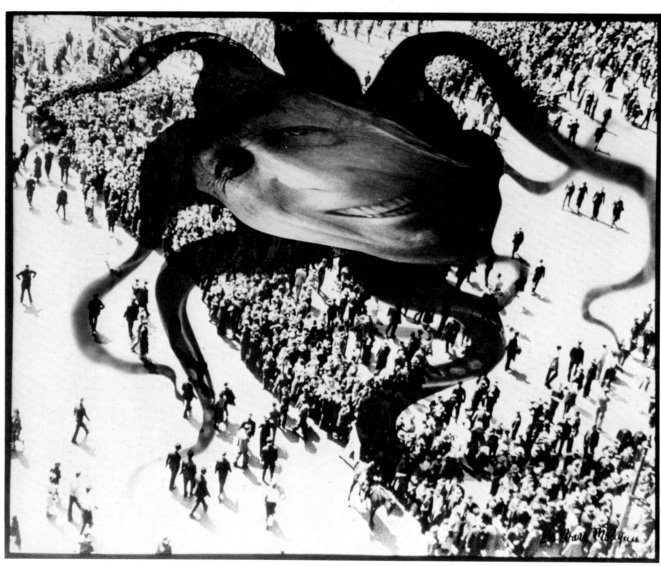

Hearst over the people (photomontage), 1938–39

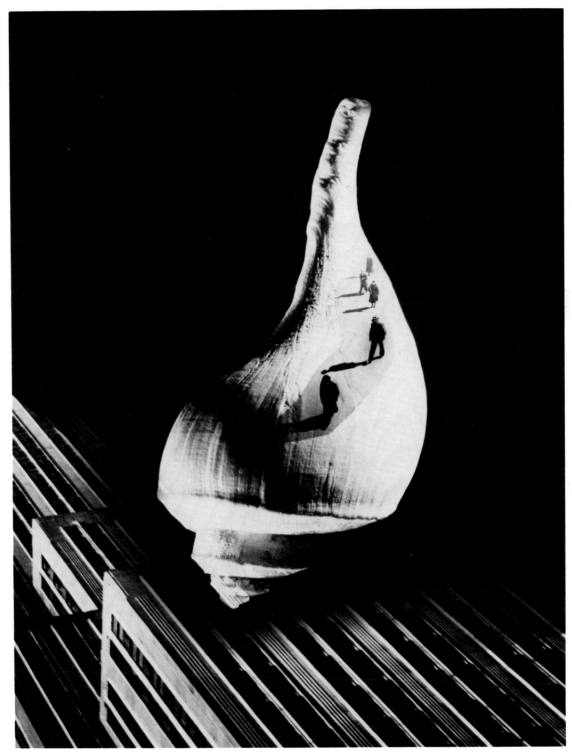

City shell (photomontage), 1938

Beech tree IV, 1945

Brothers, 1943

Beaumont Newhall, 1942

Nancy Newhall, 1942

DIANE ARBUS
1923-1971

Diane Arbus was a huntress stalking photographs. To dare gave her great delight, and subjects thought impossible to capture were all the more appealing to her. Each challenge she successfully confronted was replaced by another at least as difficult. Her lists of situations and people to be photographed were unending. On a huge blackboard behind her bed, she kept adding names and scratching off others. As she explained, "My favorite thing is to go where I've never been."

She commented to friends that her need for daring originated in an overly protective, overly organized childhood in which she broke the monotony and defied the security of home by being naughty, by doing the don't-do's. But if that is how she began, the driving forces shifted as she matured, and she worked more to satisfy her own sense of personal excellence. Although she never lost her delight in the mischievous, the thrill no longer arose from rebellion. What she sought was the heady experience of achieving her own high standards. She was courageous not because her endeavors were physically dangerous, though they sometimes were, but because photographs so original, so absolutely honest and precise, so intensely private, were intellectually and emotionally exhausting to make.

Arbus's photographs are the proof of her daring; they are, her friend Marvin Israel observed, her trophies, and without them, her stories of the hunt would have been more difficult to believe. What separates them from the trophies of other adventurers is that they continue to exist after the event they commemorate has been forgotten. For Arbus and the subject, the photographs prolong a unique moment between them. To everyone else, the photographs are more, not less, complex than the moment preserved.

What she rebelled against in her childhood was not the restrictions but the loss of reality imposed by such a sheltered world. Diane Arbus was born in 1923 in New York City, the daughter of comfortably wealthy Jewish parents. Her father, David Nemerov, owned the prosperous (now defunct) Fifth Avenue store called Russeks, which his wife's family had founded. Arbus was raised in an apartment on Central Park West and attended Ethical Culture and Fieldston schools. When she was 13, she met Allan Arbus, and they were married five years later. After sampling other careers, they became fashion photographers and received her father's account. They went on to become a successful photographic team for almost twenty years. As their daughter Doon recently wrote, "He would take the pictures. She would get the ideas for them. She was the first to quit."

As she had rejected her family's values, she rejected fashion and went on to look for experiences less fictitious, more factual, and also to respond to a growing sense of self-awareness. Her younger daughter Amy said in a recent radio interview, "She never realized that as a woman she really could have her own style, do her own work. She had always thought that to help Pa do his thing was all there was to it. So it took her awhile to get to that place. It happened with us getting older and less responsibility. . . . I think she was relieved that there was more to it than that."

In the late fifties, Arbus began to strike out on her own; seeking direction, she took a class with Lisette Model, who in a sense gave Arbus her license to define her territory, which, as she told Model, was "evil." "I think," Doon has since explained, "what she meant was not that it was evil, but that it was forbidden, that it had always been too

dangerous, too frightening, or too ugly for anyone else to look on. She was determined to reveal what others had been taught to turn their backs on." Arbus was aware that in social intercourse there are unspoken agreements about being nice, particularly about not mentioning each others' peculiarities, those quirks in appearance that make each unique. She was fascinated by flaws, these details wherein the differences lay.

At first she photographed those people obviously different, too different to permit polite society to ignore their distinctiveness—freaks and eccentrics. One of the really disconcerting aspects about her photographs of those who by birth or by choice are deformed or distinctive is that they stare back with relaxed acceptance of their being. Their marks of distinction are too great for them, or for the viewer, to ignore. Arbus respected them tremendously. "Most people go through life dreading they'll have a traumatic experience," she once said to a reviewer in explanation of her awe. "Freaks are born with their trauma. They've already passed it. They're aristocrats."

Arbus began to question why ugliness, deviations, and flaws should be unacceptable. What we make of something is not what it physically is, and she depicted her subjects with a stark directness beyond value judgments. For her, existence was amoral, even trans-moral. She explained to her class, "There are certain evasions, certain nicenesses that I think you have to get out of. . . . Now, I don't mean to say that all photographs have to be mean. Sometimes they show something really nicer in fact than what you felt, or oddly different. But in a way this scrutiny has to do with not evading facts, not evading what it really looks like."

Later, less interested in what was "evil" but still pursuing what was specifically different, she began to photograph ordinary people out of an awareness of "the gap between intention and effect . . . a point between what you want people to know about you and what you can't help people knowing about you." Because people are not content with the exterior they are given, they create a whole other set of peculiarities in an effort to project a different image. While each person is unique, most want to be unique in another way. Arbus photographed the resulting combination of given and sought. Some efforts to change are more obvious than others: men dressing like women, and vice versa. Others are less drastic, such as middle-aged women dressing like teenagers. There are also the costumes that identify one person with another, as in the case of twins, or with a cause, as in the case of the protesters, or even those who disguise identity with masks.

In not attaching values, in not seeking out people only for their physical distinctions but for their uniqueness in the context of their whole being, she was not exploitive. She had tremendous ability to empathize, which allowed the subjects to trust her. Some of the people she sought out to photograph became her friends, or at least she continued to see them over a period of years. "Actually, they tend to like me. I'm extremely likeable with them. I think I'm kind of two-faced. I'm very ingratiating. It really kind of annoys me. I'm just a little too nice. Everything is *Oooo.* I hear myself saying, 'How terrific,' and there's this woman making a face. I really *mean* it's terrific. I don't mean I wish I looked like that. I don't mean I wished my children looked like that. I don't mean in my private life I want to kiss you. But I mean that's amazingly, undeniably something. . . . There are always two things that happen. One is recognition and the other is that it's totally peculiar. But there's some sense in which I always identify with them."

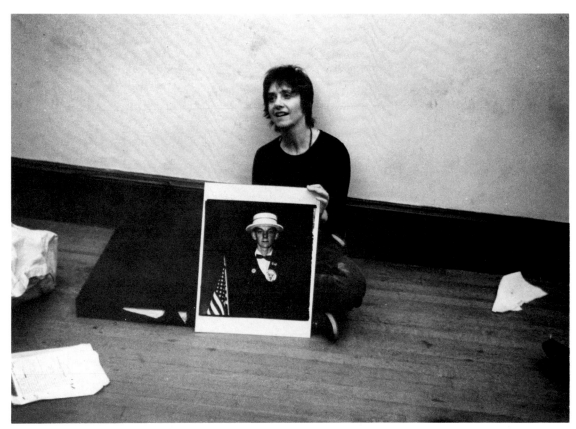

Portrait by Cosmos

Despite her empathy, she realized that "It's impossible to get out of your skin into somebody else's. . . . That somebody else's tragedy is not the same as your own." Her empathy was always balanced by her sense of herself as a photographer, her desire not to avoid the facts. She was both the friend who has been beyond the exterior into personality and the stranger who critically picks apart appearance. She was simultaneously detached and intimate. While she was empathetic, she realized the camera would be clinical. The resulting photograph would combine her ideas, the subjects' responses to her, and the camera's indiscriminate record.

Arbus's approach to photography was as radical as her subject matter. Her sources were not confined to the conventional history of photography; she was influenced in part by the snapshot and news photography. For reviewer John Scanland, "Arbus's tack was to intensify, rather than conventionally avoid, the horrors of the snapshot: Direct flash with its hideous shadows; the purposeful distortion of human features by a wide-angle lens used close to the subject; and the sloppy, often repulsive otherworldliness of random composition." She abhorred the photographs of those self-consciously aware of themselves as artists: Edward Weston, Ansel Adams, and Harry Callahan. The photographers she most respected were those who understood darkness, particularly Weegee, Brassai, and Bill Brandt.

She was unique in both her style and in her choice of subjects because she wanted to be. As Doon observed, "Imitation was not for her the sincerest form of flattery, but an absolute horror." In the late 1960s her pictures had a ragged black line around them, in part to avoid association with the sharp edges of a magazine print and in part from her fatigue with orderliness, but as others began to imitate it, she dropped it. She changed the size of her prints from the traditional eight by ten to sixteen by twenty. Every few years, she would switch the type of camera she used in order to change her imagery.

Arbus rarely exhibited or published her noncommercial photographs. She was so secretive about her work that even her closest friends and her children rarely saw a body of her work. Israel observed, "Diane has written that 'a photograph is a secret about a secret, the more it tells you the less you know.' That odd riddle is a clue to her. Whatever she was and whatever she said she was, was in some sense disguised."

Since her suicide in July 1971, she has become increasingly legendary. To some extent this is attributable to the upsurge of interest that often occurs after an artist's death, and also to society's tendency to assume that a woman artist's suicide vindicates the assumption that women are too delicate for the rigors of artistic creation. But Susan Brockman, a friend, observed, "Diane was a myth in her own way before she died. A lot of people related to her that way; it was just a smaller group of people. She was a very literary character, very classical, which is unusual in this time. . . . I think people were always affected by her. Well, now that it is on such a large scale, it is a little strange, it is a lot strange, but it is not out of keeping with her in a certain way."

Probably most distressing to those who knew her is the insistence of many that she killed herself because she couldn't bear the ugliness of the strange world that she photographed. To this theory, Israel replied, "It is absolutely untrue. . . . Diane was delighted by the people that she met. And perhaps the one thing that gave her total enthusiasm and energy was the possibility of finding more of these people. She had an

endless curiosity and really never found despair from other people. She was very proud of what she did." Although what artists make is deeply part of what they are, the artist cannot be understood from his work. Professional joys are very separate from private agonies.

Arbus *was* very proud of what she did. In less than ten productive years as a photographer, she changed the way we see the world. She knew that she had succeeded in carving out a territory of her own, and no one could enter without reckoning with what she had done. "I mean it's very subtle and a little embarrassing to me, but I really believe there are things which nobody would see unless I photographed them."

Xmas tree in a living room in Levittown, Long Island, 1963

Retired man and his wife at home in a nudist camp one morning, New Jersey, 1963

A Jewish giant at home with his parents in the Bronx, New York, 1970

Man at a parade on Fifth Avenue, New York City, 1969

A flower girl at a wedding, Connecticut, 1964

A young Brooklyn family going for a Sunday outing, New York City, 1966

Albino sword swallower at a carnival, Maryland, 1970

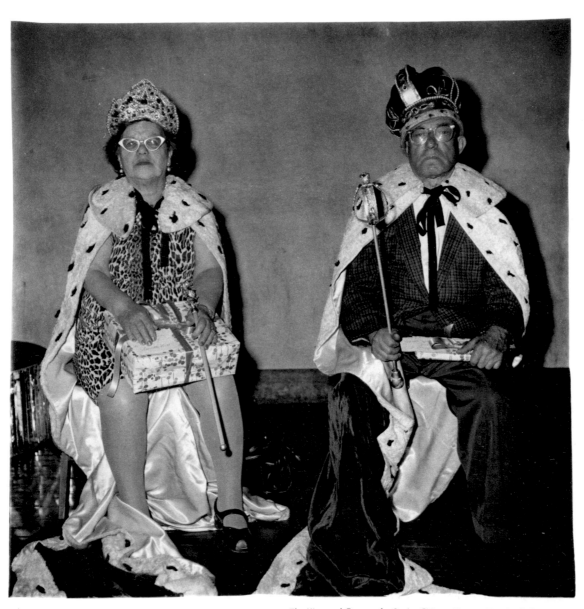

The King and Queen of a Senior Citizens Dance, New York City, 1970

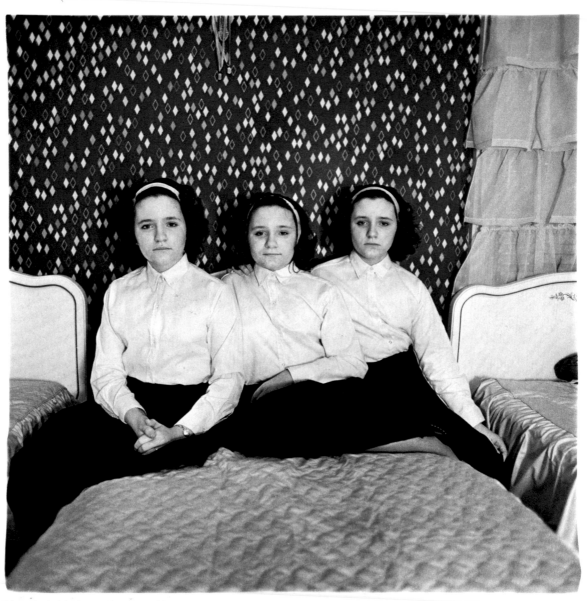

Triplets in their bedroom, New Jersey, 1963

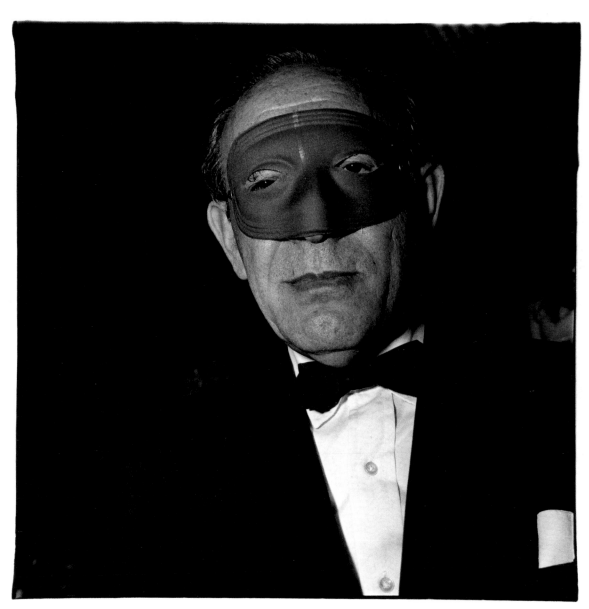

Masked man at a ball, New York City, 1967

ALISA WELLS
1929-

Pure photography, as defined by its most articulate spokesman, John Szarkowski, "is a system of picture-making that describes more or less faithfully what might be seen through a rectangular frame from a particular vantage point at a given moment." Alísa Wells has ignored the limitations imposed by these uncompromising rules of precision, descriptive detail, consistent vantage point, and coherent time. Her photographs are visual metaphors. They become tools to explore the "real" as opposed to the "unreal," her interpretation of reality.

The autobiographical nature of her work is certainly not new, it is only out of vogue. Artists and writers who identify with their subject matter are, according to Edmund Wilson, Romanticists. "They ask us to be interested in themselves by virtue of the intrinsic value of the individual: they vindicate the rights of the individual against the claims of society as a whole—against government, morals, conventions, academy or church. The Romantic is nearly always a rebel." Wells's bout with society began relatively late in life. As a mother of three, searching for more meaning to her life, she has slowly discovered that photography is a "medium to get inside and unlock some areas," using the camera "as a direct means for self-quest." Each photograph is a visual residue of an experience from which she gains an understanding, as well as a moment. When the print succeeds as a fine photograph, it is more than a record of "reality"; having a life of its own, it becomes a separate new experience, unique and distinct from that originally photographed. It is no longer a picture of, but a photograph about, something—something which is, at least tangentially, relative to Wells's own life.

Her understanding that she could use the camera for self-discovery came almost five years after she started to photograph and was a realization that was possible only with the assistance of several teachers and through the practice of Zen Buddhism. Alisa Wells was born Alice Wells in Erie, Pennsylvania, in 1929. She studied at Pennsylvania State University, married Kenneth Myers, and moved to Rochester, New York. Increasingly dissatisfied with her role as a housewife, she separated from her husband and got a job with the Eastman Kodak Company, not because she was interested in photography but because Kodak is the biggest single employer in Rochester, with good salaries and extra benefits.

In the summer of 1959, she met the man who "first initiated me into the joys and sorrows of the photographic process, an initiation of love on his part, and of joy and recognition of 'something happening to me, within me' on mine. . . . The curious thing was this same man's inability to understand why within just a few months of learning the craft, my probings into its possibilities took me on flights he had never considered either for photography, or for himself, as a Photographer or as a Man." Two summers later, she attended a workshop in Yosemite offered by Ansel Adams and by Beaumont and Nancy Newhall. Their teachings offered no solution to her probings, but Nancy Newhall, wife of the Director of the George Eastman House in Rochester, suggested that she speak with Nathan Lyons, the Assistant Director, who offered evening workshops. After meeting Lyons, Wells enrolled in his 1961–62 workshop. "I understood not a word he spoke that first night, and little in the endless ones following; but his words, gestures, challenges were speaking to something, someone deep within me." Lyons became Wells's mentor for the next eleven years. For her, the most perplexing question that he asked was "Why do you photograph?" At that time, she had no idea, but only knew that photography presented an absorbing challenge, and a purpose for living.

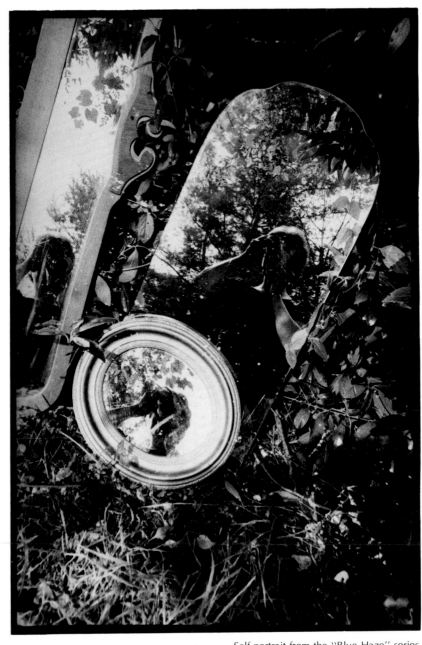

Self-portrait from the ''Blue Haze'' series

It was Lyons who raised the possibility for Wells that "the photograph may become an awakener of our sensibilities." In believing that the "eye and the camera sees more than the mind knows," Lyons affirms that we can learn from our visual experiences. At first, Wells's photographs were very much in the style of Lyons's own: four by five view-camera studies of natural forms. But she introduced two elements that have continued ever since to distinguish her work. One is a sense of emanating light, with a corresponding love for the kind of silver print that evokes such a sensation. The second is a response to the expressive potential of solarization—a darkroom process in which selected areas of the print are re-exposed to light before the print is fixed, thus causing a reversal of exposure in those areas and resulting in purple-black tones on the print. She also began to explore the concepts of time, change, and impermanence, still primary concerns in her work.

In 1962, Wells quit her job at Kodak to join the Eastman House. That same year, by mutual consent and in mutual concern for her professional status, she assumed the name of the man with whom she was living. Daniel Andrews was a source of strength, for "in addition to all the emotional support, he encouraged me in every way, down to buying the equipment and building my darkroom." For the next couple of years, she continued to photograph with the view camera, then switched to 35 mm, simultaneously changing subject interests from natural forms to man-made landscapes or, as a reviewer was later to comment, to "poetic interpretations of the human condition." An image by Man Ray that she had seen in the Eastman House collection initiated her interest in double-frame images, where one-and-a-half or two consecutive negatives are printed as one picture. She was specifically interested in the time sequence, in bringing two moments together to give birth to a new moment, a poetic experience. The association was between separate events that were always sequential in reality, but previously unrelated because of the time lag between them. In some, the time lag was greater than in others; some events were staged or provoked, others occurred without her intervention.

Wells took another of Lyons's workshops in 1965–66. That spring, Robert Fichter joined the Eastman House staff. By this time, she had begun to run exposed film back through the camera a second time to achieve "a many-momented image." Fichter was also interested in the multiple image and they began to photograph and print together, even to exchange negatives. The relationship was an intense one. As Wells has explained, "Robert and I were just feeding off the needs of one another." A productive period for both in terms of images produced, it was also an emotionally traumatic and liberating experience for Wells. "Robert's fertile imagination and print-making facility were the breaking, and breaking-through point in my life, away from a lifetime of dependence upon A MAN to solve my problems, hand me my opinions, do my work, pay my bills, admire my images, live my life, shape my future."

Up until 1967, despite increasing requests for her work for exhibitions and publications and despite a promotion to Associate Curator of Extension Activities at Eastman House, to believe in herself as an artist, Wells needed the approval of those whose opinions she most respected. She became aware that the driving force in her life had been loneliness, and the need for approval arose from her fear of it. As Lyons had once chided her, "The cliff you are poised on, so frightened of jumping off into the unknown, is only a foot high. Why the hell don't you just let go?" 1967 was also a very important year in other respects. She separated from Andrews, returned to her

maiden name, and suffered a physical and psychological breakdown. The break with dependence is symbolized by her photograph "Sue and Sam," the last photograph in her series entitled "The Glass Menagerie" that was made in 1968. That same year Fichter left Rochester to teach at UCLA, and she began to practice Zen Buddhism.

Right before Fichter left, they bought some old glass-plate negatives at an auction. Wells did not start to work on the negatives immediately; she wanted to put time between the new project and her previous work. The work, begun in the winter of 1969, came very slowly. Titled "Found Moments Transformed," the series extended her pursuit for the meaning of life. In printing the old plates according to her own interpretation, she modified the images into her own vision. She thus "discovered" her imagery within the plates, as she had previously "discovered" it in nature. Sometimes she altered the original image very little, sometimes drastically. Especially in those most radically changed—through staining, solarization, or other technical processes—her feelings of self-hate, self-destruction, and self-inquiry become most evident. In some, she systematically destroys the subjects' faces, usually the women's faces, leaving the men's unmanipulated. In others, all of the figures are oppressed or encircled by menacing shapes.

When she had completed a set of 30, the Eastman House purchased them to create a traveling exhibition. That summer, however, believing that another employee was consciously seeking to destroy the programs to which she and Lyons were committed, Wells confronted the woman and pronounced a contravening "spell" against her. The upshot was the dismissal of both employees and the resignation in protest of Lyons, who was then Associate Director and Curator of Photography. Promptly thereafter, he founded the Visual Studies Workshop in Rochester, and Wells again became his assistant, until January 1972. Lyons re-purchased the photographs that were to have formed a traveling exhibition from the Eastman House, and they became the Workshop's first traveling exhibition.

While continuing to work on the "Found Moments" series, she spent part of the summer of 1970 teaching photography and leading a zazen meditation group at Penland School, North Carolina. Here she made a series of photographs consciously related to her increasing awareness of feminine sensibilities and her ability to objectify them. She photographed herself and her physical surroundings, particularly the little cabin she lived in at Penland, in "an attempt to convey visually how a woman 'sees' herself in a new environment and the many ways she responds visually to the questioning that goes on within her—the crises, the joys, the loneliness, the sexual yearnings—how she attempts to bring some 'livable' order to the chaos within/without her." Most of these are straight photographs, some are multiple images, and some hand-colored, but all are marked with that particular quality of light to which she is partial.

Wells's photographs have both outspoken critics and staunch supporters. The former resent her corruption of pure photography for personal ends; the latter are simply moved by the images, and would reply to the critics as Alfred Barr has written: "The truth which plumbs deeply, convinces the mind, brings joy to the heart or makes the blood run chill, is not always factual." Many cannot relate to her work because her photographs are too personal. Her work is so autobiographical that it is for many viewers too intimate an encounter.

Wells has decided that self-realization has priority over making photographs. "I have realized that *some* understanding of what one's life is about is simply not enough—not quite where it's really at. The problem: how to live what one has discovered—to live one's growing vision in every moment/action of the day? Not to come to grips with what this forces upon the consciousness reduces all the problems, pains, searching, intuitive understanding resulting from the visual 'work,' to mere data—concepts to be stored and smugly displayed over cocktails or seminar tables." She left the Workshop and moved to the mountains of New Mexico, where she now lives in a house without running water, electricity, or telephone. Lacking these utilities, she has switched to Polaroid photographs, when she can afford the film, and to color slides which she can send away to be developed. She continues to photograph herself and those things closest to her as she did in the Penland series.

In a recent letter she expressed her feelings about her new life style: "Never before have I felt the courage to just be, without excuses for my 'being' . . . without looking for some man for my reason/excuse for breathing. Always have I justified my life, my every motivation, my photographs, their meaning, their right to existence. Now the real beginnings of the 'freedom' which we have discussed for many years—and a heady freedom it is, coming after so many years of reaching outward for it—to finally discover all I had to do was reach inward, and it was there waiting all the time for me."

"End of the Beginning/Beginning of the End." Berby Hollow, New York, 1963

130

Smoky Mountains, North Carolina, 1967

"Hospital/DA and RWF," July 1967

Sue and Sam, Vick Park B (from *The Glass Menagerie*), 1968

"Either/Or," Tallahassee, Florida, 1969

134

"RZC picnic," Mendon, New York, 1968

From *Found Moments Transformed*, 1969–72

From *Found Moments Transformed,* 1969–72

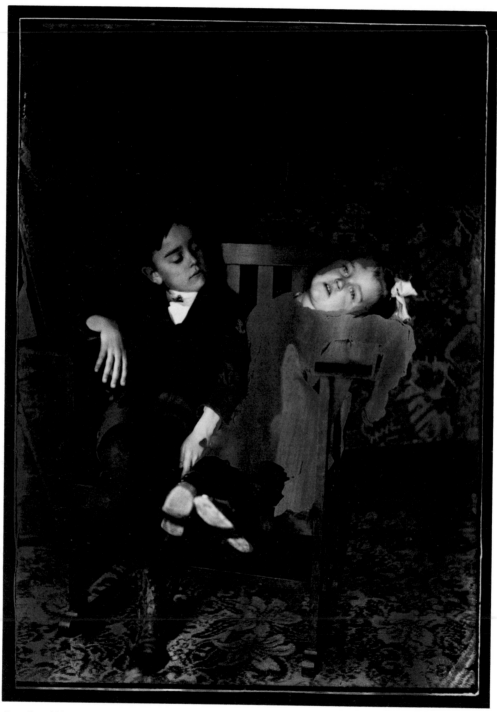

From *Found Moments Transformed,* 1969–72

From the ''Blue Haze'' series, Penland, North Carolina, 1970

JUDY DATER
1941-

The most startling aspects of Judy Dater's portraits of urban women are their accepted sexuality and the intensity with which the sitters confront the camera. Without exploiting their sexuality, Dater portrays each woman as an individual, at ease with her body. Any emphasis on the body as beautiful originates with the sitters themselves, women who are marked by urban sophistication, as Dorothea Lange's women were marked by simple country ways.

The emotional intensity of these portraits is the kind rarely made public except in the best theatrical moments. The viewer may be conscious that a relieved sigh followed the shutter's click, but for a brief electric moment, something was revealed. Whether it was a pure moment of the soul or a performance for the camera, it doesn't ultimately matter. It was probably something of both. Nevertheless, the experience is as convincing as the moment is memorable.

Dater began her self-imposed project dealing with the urban woman in 1968. Raised in Southern California, she studied art at UCLA for three years, then in 1962, transferred to San Francisco State College. In her last semester, she took a photography course, liked it, and decided to stay on for a master's degree. At first, she photographed a wide variety of subjects—landscapes, friends, still lifes, buildings, street scenes—but whenever she took a photograph without human subjects, she felt something was missing. She liked photographing her friends, but also wanted to photograph strangers, particularly women.

Since the mid-1960s, Dater has photographed with Jack Welpott, a teacher at California State University whom she married in 1971. The urban woman series took form when they decided to look for people they both wanted to photograph. Their interest focused on the people, but also on the different ways that each of them would photograph the same subject. At first, their subjects were young, attractive California women, whom they met at parties or at art openings, and photographed later in the women's homes. Most of the women were related to the arts—as artists, wives of artists, or just as enthusiasts or patrons. Dater feels that all are uniquely contemporary women. In titling a recent exhibition of their respective photographs ''MS.'', Welpott explained, ''This new designation for women sums up something of the special nature of the females of this decade. . . . Their heads are in a completely different place from those of their mothers . . . the girls in this exhibition . . . are for the most part the free spirits among women.''

Each subject is chosen because there is something visually interesting about her that intrigued the photographers. Very little time is spent talking during that first encounter, and because they are strangers, there is always tension about the next meeting. Dater says that she could never preconceive photographs before the session even if she wanted to, because ''the houses are always such a surprise, never what I expected.''

The subjects' homes are catalysts in Dater's perceptions. On arrival, she usually spends some time talking to the person. Then she prefers to tour the house, noting the environment they have made for themselves, and particularly what they collect. ''Sea shells, plants, oriental art, cookbooks, religious paintings—whatever people select says a lot about them. Some things reflect a sensitivity to beauty; other people surround themselves in ostentatious junk.'' In her photograph of Joyce Goldstein, Dater included the cooking utensils, in reference to Goldstein's profession as director of a

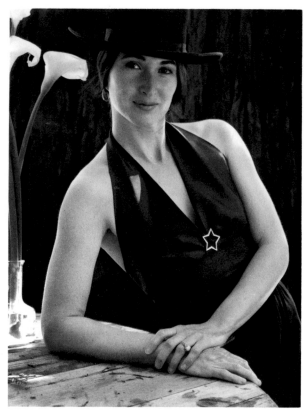

Portrait by Jack Welpott

cooking school. ''They are cooking utensils but also more. That black cleaver is very ominous and there is something very clinical about all of the tools and the way they are hanging.''

The subjects' costumes are equally important to Dater. Usually the photographers first see the subject dressed as they want to photograph her, and they start the session with that outfit. The woman in the man's suit, Dater saw in a restaurant. She made other photographs of the woman in ordinary clothes, but found them uninteresting; the suit was really what inspired her. If people let them—and surprisingly they usually do—Welpott and Dater go through the subject's closet and select another outfit. Sometimes people change clothes during the sitting and sometimes not. The clothing and the settings of most are neither typically middle class, nor haute couture, but often the high fashion of the rock culture: beads, leather, fringes, feathers, and lace, somewhat reminiscent of turn-of-the-century bohemia with a touch of nostalgic Hollywood flair.

Dater considers herself within the tradition of interpretive portraiture. Her intention is not to document, nor to glamorize. For her the most important thing ''is that people reveal themselves to the camera and express something about themselves which

definitely exists, though it may be hidden—perhaps even from themselves." A deeper perspective of Dater is gained by comparing her work with Welpott's; the differences in approach and the differences in the sitters' reaction to the photographers become evident. Welpott is interested in women because they are mysteries. If they are pretty, he relates to them sexually through the camera. As Kenda North observed in her review of their "MS." exhibition:

> The women often react to Welpott in terms of their fantasies of themselves in relationship to a man. They tend to turn on their beauty (which he is obviously seeking) and occasionally even charm—though most of them consider man a subject to be confronted rather than shyly approached. The response to Dater, who presents herself as an equally vibrant and sensuous woman, is often more candid and direct. It's difficult for a woman to maintain her fantasy in the face of another woman, and in Dater's work the women tend to reveal an unembellished presence.

Both Welpott and Dater have photographed Joyce Goldstein. Whereas Dater photographed her in the kitchen to relate to her specific interests, Welpott was less interested in her personality. He structured his photograph as he would a landscape. He moved Goldstein into the living room, making her an element in the picture, neither more nor less important than the bentwood chair in which she sits or the Mexican candlestick on the table in the foreground.

Again, in their photographs of Twinka, there is a marked difference. Interested in her physical beauty, Welpott photographed her in a loose knit dress with nothing underneath. She is standing, casually posed against a simple interior, looking calmly at the camera. Dater's photograph is of an almost unrecognizably different woman. Twinka wears a delicate negligee and Dater asked her to pose outside where the light was brighter. She suggested that Twinka sit in the cave-like opening at the base of a redwood tree, but was very startled with Twinka's response. "I asked her to get there, but I didn't tell her to put her hand up like that, and of course I didn't tell her to get that expression on her face, but I did ask her to hold it."

Dater works with a four-by-five view camera because its large-format negative gives the clearest possible delineation to detail and texture. In her attention to fine print quality, she is working within a very strong West Coast tradition stemming primarily from Edward Weston. In the late 1960s, Dater became a founding member of a group that was consciously part of that same tradition. The Visual Dialogue Foundation was a dynamic group of photographers, most of them recent graduates from San Francisco State. They wanted to meet as an incentive to keep working. "We were nervous and banded together to keep warm, and also we hoped to do something constructive for photography," Dater remembers. "Those get-togethers were valuable, because we would work to have something to show. Also, it was a good way to exhibit. As a group, we produced a portfolio, two major exhibitions with catalogues, and a lecture series of prominent photographers and photohistorians." Now that most of the members have moved away from San Francisco, the group is relatively inactive.

Dater and Welpott are now beginning to photograph people other than women between the ages of twenty to forty—couples, men, and people even more colorful. When the project first started they were unclear about its ultimate direction. Slowly the past work has defined and influenced the direction of continuing involvements. Dater doesn't really like to analyze her work; she feels that dissection destroys its spontaneity, since most of her work comes from a gut-level response.

143

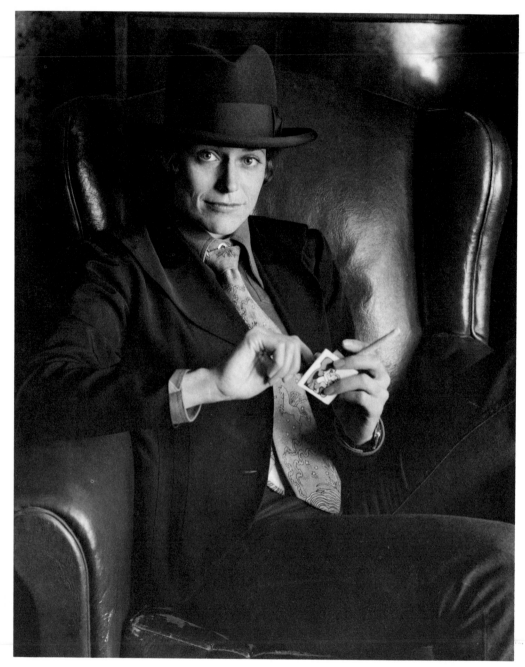

Laura Mae, 1973

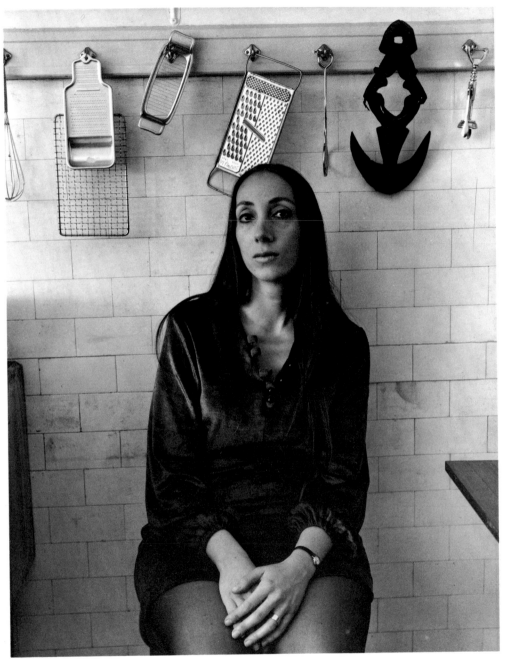

Joyce Goldstein in her kitchen, 1969

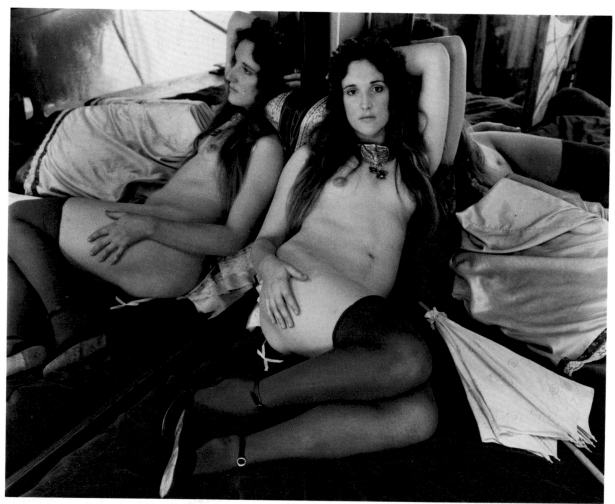

Maureen, 1972

146

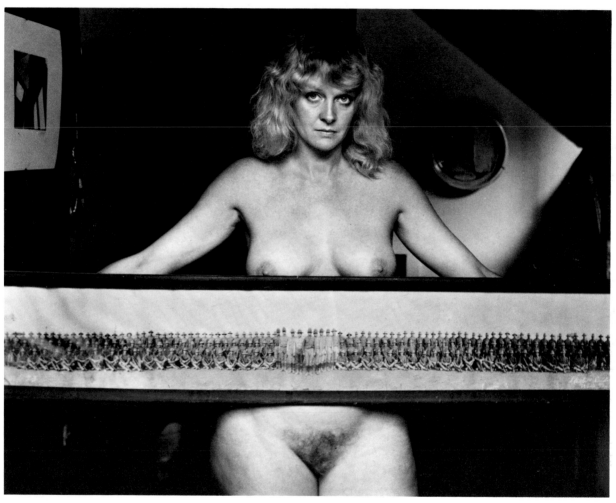

Cheri, 1972

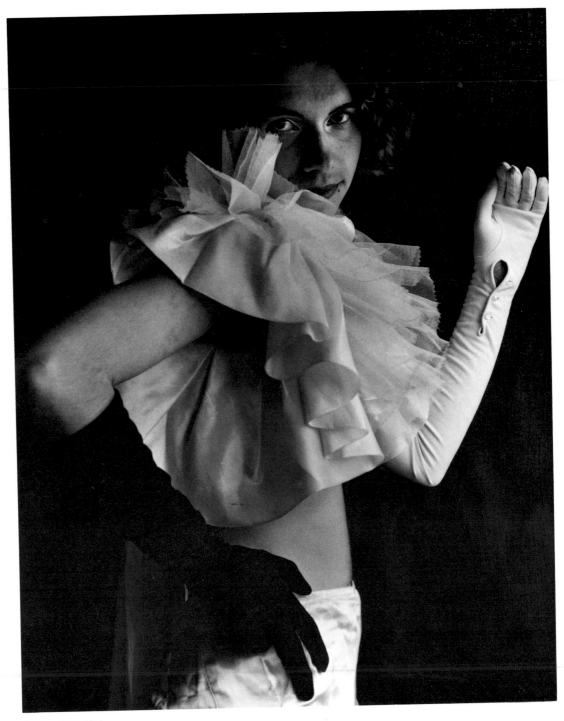

Aarmoor Starr, 1972

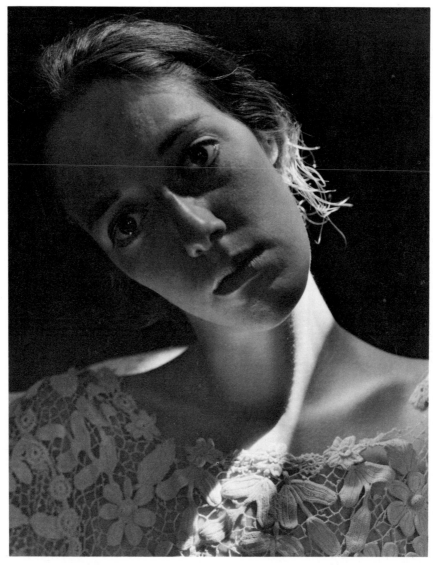

Gwen, 1972

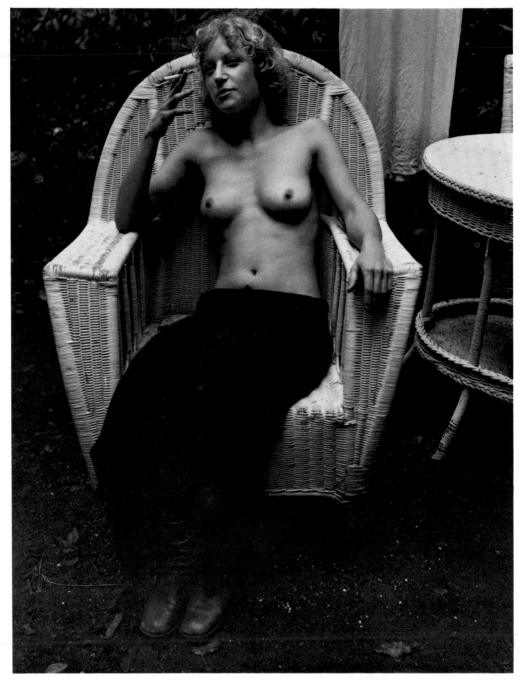

Maggie, 1970

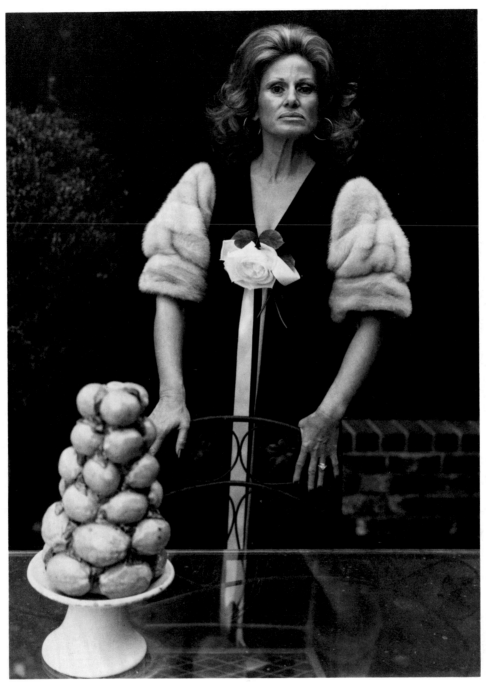

Woman, Beverly Hills, 1972

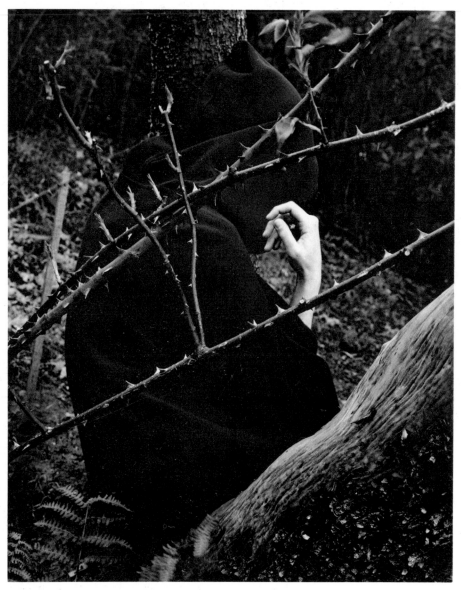

Lucia, 1972

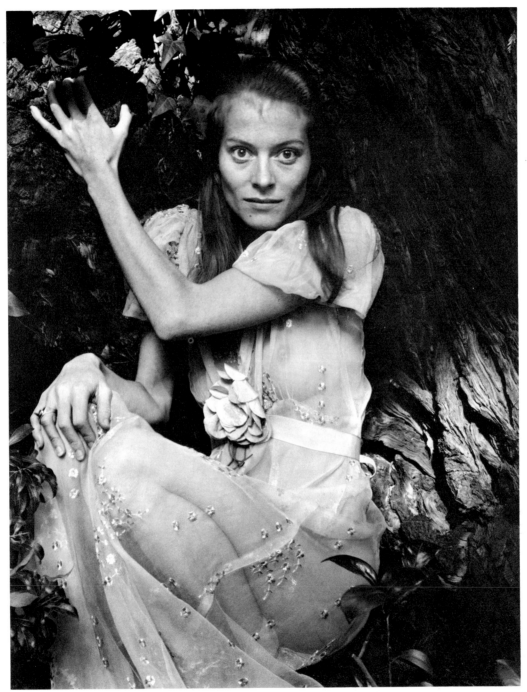

Twinka, 1970

BEA NETTLES
1946-

In my images I am attempting to make fantasies visible.

Through them I am investigating and sharing myself, my life, and the landscape that is around and within me. Family ties, twenty years spent in the green and growth of Florida, and dreams that I remember in the morning are elements in my work.

I feel that rather than "taking" photographs, I am making them. I freely use any materials to make my images . . . thread, dust, cloth, plastic, pencil, mirrors, as well as photographic paper and film. I'm trying to stretch and share the limits of my imagination: that is why and how I continue to work.

This precise and comprehensive description of Bea Nettles's work was written in 1972 before she had begun to make little books of snapshots such as the sequence reproduced here. For the previous four years she had created objects of a wide variety of textures, shapes, and sizes, employing a variety of photographic processes, together with any other materials and processes that she felt would obtain the desired result.

Her interest in the snapshot is in effect a return to the images that had fascinated her as a child. Her first camera was a red plastic one that her grandmother had received for buying a sewing machine. Although Nettles only photographed for a couple of years then, she saved the pictures and some of these early images appear in both her mixed-media objects and in the new sequences.

It was in college that Nettles picked up photography again. Her father loaned her his camera, a 120-roll film Yashica, but as a painting major, Nettles wanted more to "happen" than just the record of the subject as in a straight photograph. She started to tone the photographs, then to cut the images up and reassemble them. When she took photographs, she was only interested in specific areas or specific things or even a feeling of something that wasn't there visually. Later she would work these partial photographs in with others of a similar feeling. She continued to concentrate on photography; by her last year in graduate school, photographic elements appeared in most of her works.

In 1972, when Nettles was teaching at the Center of the Eye in Aspen, Colorado, she renewed her interest in snapshot photography. She was working with a borrowed 35 mm half-frame camera that soon jammed. Then she began to use an inexpensive, plastic instamatic, and the results intrigued her. She had not liked the photographs made with the Yashica and the half-frame cameras; the images were too precisely factual, and they bored her. With the cheaper camera there was a certain lack of control—what was seen in the viewfinder and what was isolated through the lens was not exactly the same—which she liked. The framing of each photograph was almost accidental. With the poor-quality plastic lens of the cheap camera, focus was unpredictable. The exposure on the edges was uneven and very often a black line would appear across the top of the image. This casual approach is closer to her personal style of working impulsively, without time spent considering the proper camera angle or perfect exposure.

Continual experimentation is vitally important to Nettles. When creating mixed-media objects, she has learned to work with many processes including gum bichromate,

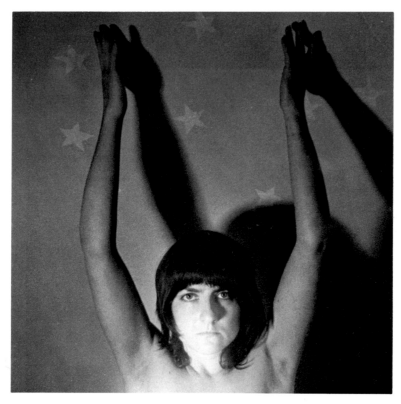

Self-portrait

photosensitized linen, cyanotype, silkscreen, as well as the traditional silver processes. Working with the instamatic she constantly uses it in new situations to test its range and limitations. Now she is beginning to privately print her books of snapshots. The first one was "Events in the Water." She made the half-tones herself and found a non-union printing shop where she could help with the printing. Nettles did the finishing and binding by hand. "Events in the Water" is the first sequence that uses the elements—earth, air, fire, and water. "Events in the Sky" is completed and the two others are contemplated.

"Escape," which is used here, is the third sequence in her snapshot series. Completed in November 1972, it deals metaphorically with different kinds of escapes. It is also a literal record of a trip home to Florida. She began to work on "Escape" when she was living in Philadelphia and, feeling trapped, she needed to get away from the concrete and crowds to a house with a yard in a smaller town. Her anxiety was amplified when a mugging occurred in her building where Nettles could hear the woman's scream. She introduces "Escape" with the flight of the bird and with the palm trees and clouds—her personal symbols of Florida which recur frequently in her work. The second image is the building where she was living, which was a prison to her. She reinforces that impression in the third photograph, a picture of one of her own pieces

in which plastic birds are trapped inside a plastic sky. In front of that same piece in the next image, Bea Nettles daydreams of escapes: through the water, into oneself in a mirror, on a plane. Then she literally takes the plane to Florida, both a real and remembered place. Her escape is accomplished. The last three photographs have a double meaning for Nettles. She recognizes that marriage is a form of escape for some people, so that on one level the bride, the house, and the child connect. However, the bride is actually Nettles's sister; Bea felt that her sister was not escaping, only changing the direction of her life. On another level, the child is a winged fairy, bringing the viewer to the new house, which in the end is more inviting than the first one.

Not all of the sequences are as related in content as "Escape." In some the relationships are purely visual, creating a *déjà vu* effect through repeated shapes. There are some visual relationships in "Escape," such as the little girl's rib cage and the pattern of the boards on the house gable, but these are secondary concerns. In other sequences she is more provoked by a sense of fun. Images are paired on the basis of shape relationships or of similar moods or gestures. She likes to play across the centerfold, relating images rhythmically.

Recurring throughout Nettles's work are the constants of her home, Florida landscapes, self-portraits, and dreams mixed in complex tapestries with images of new friends, events, and environments, but with no regard for actual time or traditional logic. Personal symbols are infused with allusions to ancient myth and religions. She doesn't adhere to traditional interpretations of these ancient systems, but portrays them as they relate to her fantasy/dreams. The only time that she closely followed the established structures was in the set of Tarot cards completed in the spring of 1972. These photographic cards are based on the traditional deck and are easily recognizable as such, yet here too one is aware of Nettles's free use of gesture and expression.

Nettles's mother has been a strong influence on her daughter's direction. Theirs has always been a close relationship, but another dimension was recently added when Mrs. Nettles started writing poetry and sending it to her eldest daughter. They respect each other as artists as well as women. Nettles has often made photographs in response to her mother's poems, while Grace Nettles has written poems for special events such as Bea's one-woman exhibition at the Light Gallery in 1972. Recently her mother wrote a poem that portrays both of them. When Bea Nettles first heard it over the phone she said, "That's me," to which her mother replied, "It's me too."

The Woman with the Iron Desire

There was a woman with an iron desire,
And for its sake she went without.

Hungry, and often cold,
She echoed through her house,
Rising to work, and sleeping to dream her work
Awake.

Dreaming she'd make one thing
Called beautiful,
And make it strong
To outlast everything but flowers.

"ESCAPE," 1972

SELECTED BIBLIOGRAPHY

Käsebier:
Charles H. Caffin, *Photography as a Fine Art*. New York: Doubleday, Page & Co., 1901 (reprinted 1972).

Johnston:
(with Henry Irving Brock) *Colonial Churches in Virginia*. Richmond: Dale Press, 1930.

(with Thomas Tileston Waterman) *The Early Architecture of North Carolina*. Chapel Hill: University of North Carolina Press, 1941.

(with Frederick Doveton Nichols) *The Early Architecture of Georgia*. Chapel Hill: University of North Carolina Press, 1957.

The Hampton Album. New York: Museum of Modern Art, 1966.

Pete Daniel and Raymond W. Smock, *Frances Benjamin Johnston's American Album*. Urbana: University of Illinois Press, 1974. (in press).

Bourke-White:
Eyes On Russia. New York: Simon and Schuster, 1931.

U.S.S.R. Photographs. Albany, N.Y.: Argus Press, 1934.

(with Erskine Caldwell) *You Have Seen Their Faces*. New York: Viking Press, 1937.

(with Erskine Caldwell) *North of the Danube*. New York: Viking Press, 1939.

(with Erskine Caldwell) *Say, Is This The U.S.A*. New York: Duell, Sloan and Pearce, 1941.

Shooting the Russian War. New York: Simon and Schuster, 1942.

They Called It "Purple Heart Valley." New York: Simon and Schuster, 1944.

"Dear Fatherland, Rest Quietly." New York: Simon and Schuster, 1946.

Halfway to Freedom. New York: Simon and Schuster, 1949.

(with John La Farge) *A Report of the American Jesuits*. New York: Farrar, Straus and Cudahy, 1956.

Portrait of Myself. New York: Simon and Schuster, 1963.

Theodore M. Brown. *Margaret Bourke-White: Photo-journalist*. Ithaca, N.Y.: Cornell University Press, 1972.

The Photographs of Margaret Bourke-White. Edited by Sean Callahan. Greenwich, Conn.: New York Graphic Society, 1972.

Lange:
(with Paul Schuster Taylor) *An American Exodus: A Record of Human Erosion*. New York: Reynal & Hitchcock, 1939.

The American Country Woman. Fort Worth: Amon Carter Museum of Western Art, 1966.

Dorothea Lange. New York: Museum of Modern Art, 1966.

Abbott:
(with Elizabeth McCausland) *Changing New York*. New York: E. P. Dutton, 1939.

A Guide to Better Photography. New York: Crown, 1941 (reprinted as *New Guide to Better Photography,* 1953).

The View Camera Made Simple. Chicago: Ziff-Davis, 1948.

(with Henry Wysham Lanier) *Greenwich Village Today and Yesterday*. New York: Harpers, 1949.

Eugène Atget Portfolio: Twenty Photographic Prints From His Original Glass Negatives. Edition of 100 portfolios of prints made by Abbott, with introduction. 1956.

The World of Atget. Text and editing by Abbott. New York: Horizon Press, 1964.

(with E. G. Valens) *Magnet*. Cleveland: World, 1964.

(with E. G. Valens) *Motion*. Cleveland: World, 1965.

(with Chenoweth Hall) *A Portrait of Maine*. New York: Macmillan, 1968.

(with E. G. Valens) *The Attractive Universe*. Cleveland: World, 1969.

Berenice Abbott: Photographs. New York: Horizon Press, 1970.

Morgan:
Martha Graham: Sixteen Dances in Photographs. New York: Duell, Sloan and Pearce, 1941.

(with Edgar Kaufmann, Jr.) *Prestini's Art in Wood*. Lake Forest, Ill.: Pocahontas Press, 1950.

Summer's Children: A Photographic Cycle of Life at Camp. Scarsdale, N.Y.: Morgan & Morgan, 1951.

Barbara Morgan: Monograph. Hastings-on-Hudson, N.Y.: Morgan & Morgan, 1972.

Arbus:
Diane Arbus: An Aperture Monograph. Millerton, N.Y.: Aperture, 1972.

Nettles:
Events in the Water. Privately printed, 1973.

Events in the Sky. Privately Printed, 1973.

(with Grace N. Nettles) *The Imaginary Blowtorch*. Privately Printed, 1973.